Mexican Indian Folk Designs

252 Motifs from Textiles

Irmgard Weitlaner-Johnson

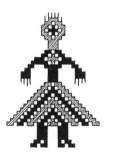

Dover Publications, Inc.

New York

Published in Canada by General Publishing Company, Ltd., 30 Lesmill Road, Don Mills, Toronto, Ontario.
Published in the United Kingdom by Constable and Company, Ltd., 3 The Lanchesters, 162–164 Fulham Palace Road, London W6 9ER.

This Dover edition, originally published in 1993, is a new selection of illustrations from the two-volume *Design Motifs on Mexican Indian Textiles*, originally published by Akademische Druck- u. Verlagsanstalt, Graz, Austria, in 1976. The present volume retains the general sequence of material of the original volumes, and the captions are based on the original text. A new Publisher's Note, derived from the original frontmatter, has been added.

DOVER *Pictorial Archive* SERIES

Manufactured in the United States of America
Dover Publications, Inc., 31 East 2nd Street, Mineola, N.Y. 11501

Library of Congress Cataloging-in-Publication Data

Weitlaner-Johnson, Irmgard.
 [Design motifs on Mexican Indian textiles. Selections]
 Mexican Indian folk designs : 252 motifs from textiles / Irmgard Weitlaner-Johnson.
 p. cm. — (Dover pictorial archive series)
 A selection of illustrations from the author's two volume Design motifs on Mexican Indian textiles, published in 1976.
 ISBN 0-486-27524-8 (pbk.)
 1. Indians of Mexico—Textile industry and fabrics. 2. Textile design—Mexico—Classification. I. Title. II. Series.
F1219.3.T4W4425 1993
745.4'089'97072—dc20 93-48
 CIP

Publisher's Note

THE PRESENT VOLUME is a new selection of illustrations from the scholarly, carefully researched two-volume work *Design Motifs on Mexican Indian Textiles* by Irmgard Weitlaner-Johnson. The aim of the original and of this new version is to stimulate interest in the artistic creativity of Mexican Indian textiles by acquainting the reader with a large number of different design elements (and significant variants) associated with Mexican Indian textiles.

Two hundred fifty-two designs, taken from motifs on textiles from twenty ethnic groups, are included. They have been arranged by ethnic group, in a geographical sequence from the northwest to the southeast of Mexico. A map showing the location of thirty-five Mexican ethnic groups, including those represented in this volume, will be found on page iv.

The designs were transferred to paper by three methods: The majority were derived by reconstructing the designs on squared paper; some were traced directly onto paper from the source material; a few were drawn freehand. The captions accompanying the designs include the names of the ethnic groups that are the sources of the designs, and a description of the structural elements of each design and the type of textile from which each was taken. English-language descriptions of the textiles are given in the captions, in place of the traditional Mesoamerican names. A brief description of the more common textile types, with their Mexican Indian designations, follows. No attempt has been made to convey the extent of color usage in the production of Mexican Indian textiles, although the ethnic populations had developed the art of creating and using animal, vegetable and mineral dyes with great sophistication by the time of the Spanish Conquest.

Garment and textile types are common to all Mexican Indian peoples. Among the most common—and most decorated—are the *huipil*, a woman's sleeveless tunic-like garment; the *faja*, a sash or belt worn by men and women; the *enredo*, a wraparound skirt; the *quechquemitl*, a woman's shoulder cape; the *servilleta*, a square or rectangular cloth used for covering food or for ceremonial purposes; and the *talega*, a woven pouch or bag. Almost all the designs of these traditional forms are pre-Columbian in origin.

The various elements found in the designs are all widely used and reflect the natural environment, the enduring place in the culture of pre-Columbian imagery and in many instances the encroachment of Western influence. Geometric figures such as triangles, diamonds, zigzag lines, squares, rectangles and to a lesser extent chevrons and parallelograms are often found singly or combined in repeating patterns as borders or as background fill-in for allover patterns. Bird forms appear in almost every type of Indian textile. They range from small simple designs to large elaborately ornamented representations of multiheaded eagles. Animal forms (dog, monkey, horse, bull, lion) are all widely used. Plant motifs are also used extensively, including the Tree-of-Life motif, often seen as a free-standing design in combination with animal motifs, typically butterflies and hummingbirds, and other plant motifs. In many cases, the motifs themselves have become so conventionalized or stylized that they seem unrecognizable. A traditional device, the *ilhuitl* motif, comprising an S-motif, is ubiquitous and gives rise to many variations, including Z- and X-motifs, angular scrolls and spirals.

The breadth of expression and artistry found in these designs is a tribute to the Mexican Indian weaver's craft. The designs, passed on from mother to daughter, represent a visual tradition that dates back to the pre-Columbian period. Although there are virtually no extant examples of textiles dated prior to the mid-nineteenth century, a strong link to the designs of pre-Columbian Mexican Indians can be observed in the representations of clothing in stone sculptures, figurines and ceramics. Many pre-Columbian designs are clearly discernible in the work of the twentieth-century weavers. The present-day designs of certain Mixteco weavers, for example, bear a striking similarity to the stone mosaic designs of the Mitla ruins in Oaxaca.

In the latter part of the twentieth century, this long and rich tradition of textile design is prey to the dictates of contemporary economics. In many villages it is no longer possible to support a family creating textiles on the traditional backstrap looms, and the traditions of weaving are already beginning to die out with the older women. The present volume is an attempt to help preserve the ancient heritage of weaving and embroidering, as practiced by Mexican Indians, whose magnificent cultural and aesthetic achievements provide ample evidence of their excellence in the textile arts.

Map of Mexico Showing Locations of Ethnic Groups

★ = Ethnic Groups Represented in This Volume

* 1 Amuzgo: Guerrero
* 2 Cora: Nayarit
* 3 Cuicatec: Oaxaca
* 4 Cuitlatec: Guerrero
* 5 Chatino: Oaxaca
* 6 Chinantec: Oaxaca
* 7 Chontal: Oaxaca
* 8 Chontal: Tabasco
 9 Chuj: Chiapas
* 10 Huasteco: San Luis Potosí
 11 Huave: Oaxaca
* 12 Huichol: Nayarit, Jalisco
 13 Maya: Yucatán
 14 Mayo: Sonora
 15 Mazahua: México, Michoacán
* 16 Mazatec: Oaxaca
* 17 Mestizo: México
* 18 Mixe: Oaxaca
* 19 Mixteco: Oaxaca, Guerrero
* 20 Nahua: Veracruz, Puebla, Hidalgo, San Luis Potosí, Jalisco, Guerrero
 21 Ocuilteco: México
* 22 Otomí: Querétaro, Hidalgo, Puebla, México
 23 Popoluca: Veracruz
* 24 Tarahumara: Chihuahua
 25 Tarasco: Michoacán
* 26 Tepecano: Jalisco
* 27 Tepehua: Veracruz, Hidalgo
 28 Tepehuan: Durango
* 29 Tlapaneco: Guerrero
* 30 Totonac: Veracruz, Puebla
 31 Trique: Oaxaca
 32 Tzeltal: Chiapas
* 33 Tzotzil: Chiapas
* 34 Zapotec: Oaxaca
 35 Zoque: Chiapas

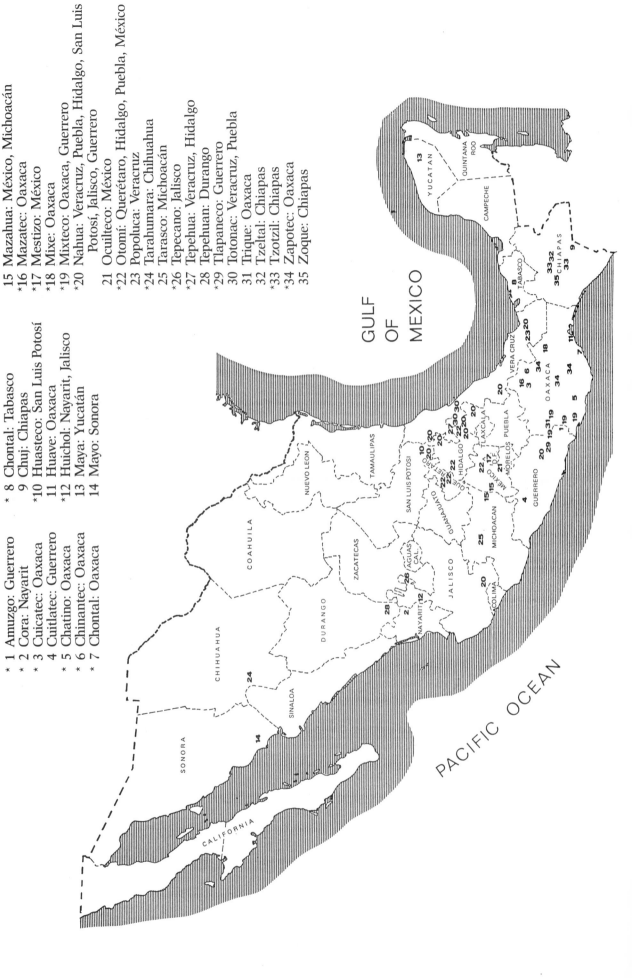

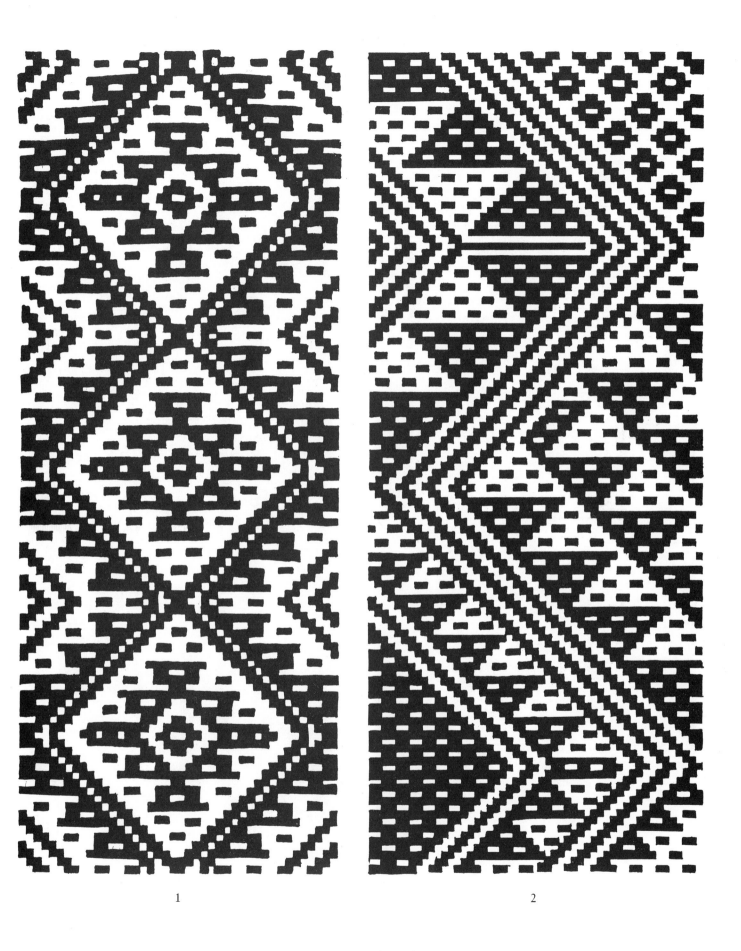

1 2

TARAHUMARA. 1: Reversible pattern of diamond-within-diamond units. Man's or wo-
man's sash. 2: Geometric motifs changing within zigzag areas. Man's or woman's sash.

1

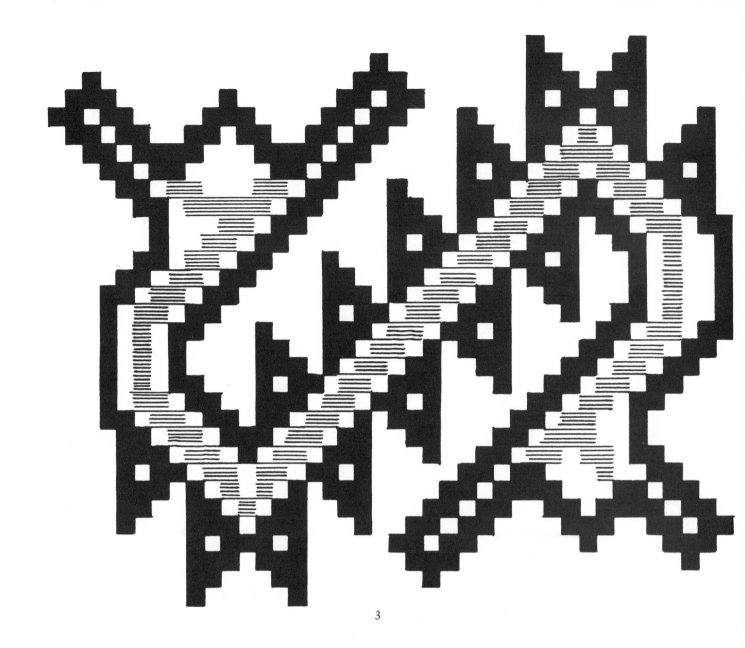

3

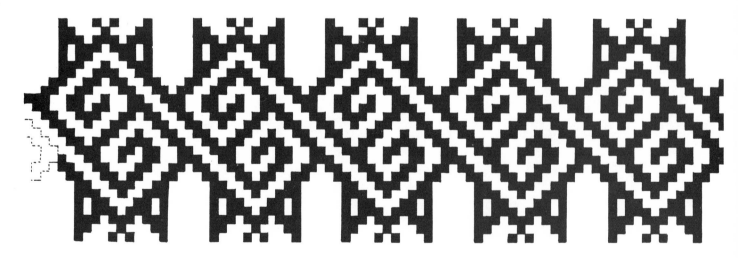

4

Tepecano. 3: Double-headed feathered serpent. Rare old woman's shoulder cape.
4: Interlocking stepped-fret motif with serrated edges. Rare old shoulder cape.

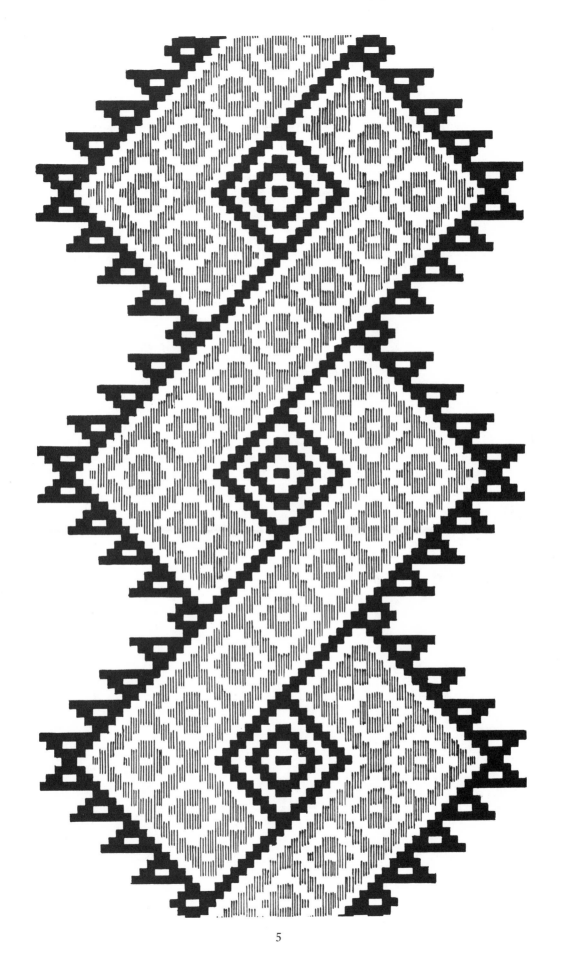

TEPECANO. 5: Twined serpent motif with serrated edges. Rare old shoulder cape. 3

6

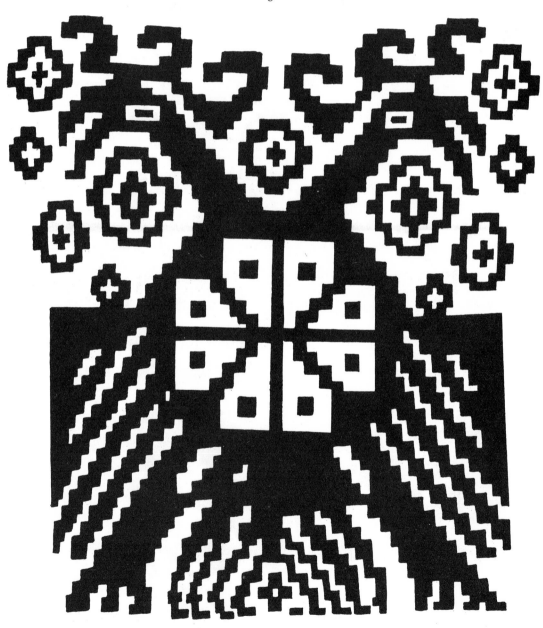

7

CORA. 6: Twisted cord motif. Bag. 7: Double-headed eagle with fancy crests in the
form of spirals; geometric forms fill in the background. Bag.

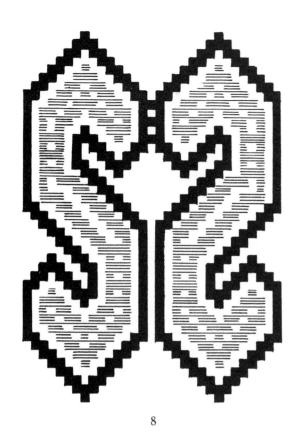

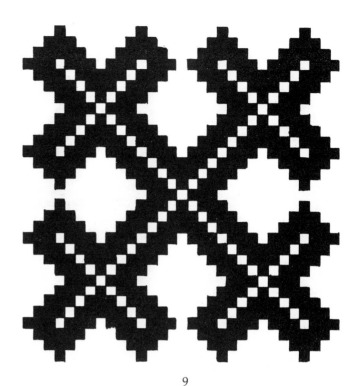

8

9

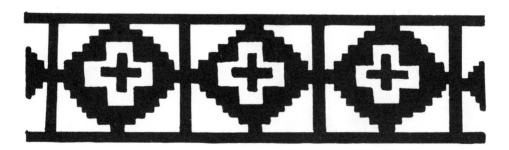

10

11

HUICHOL. 8: Pair of countered S-motifs. Woman's shoulder cape. 9: Row of crossed X-motifs. Woman's blouse. 10: Pattern of diamonds with cross in center. Bag. 11: Repeated pattern of S-motifs. Man's cape.

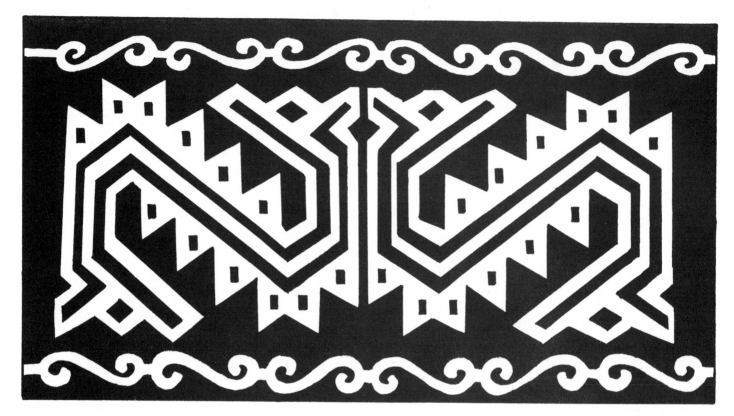

12

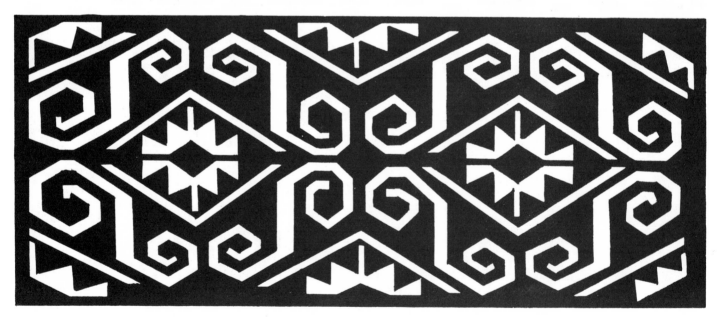

13

HUICHOL. 12: Double-headed feathered serpent, paired and countered. Sash. 13: Two pairs of S-motifs creating a four-sided unit containing a diamond and stylized floral pattern. Sash.

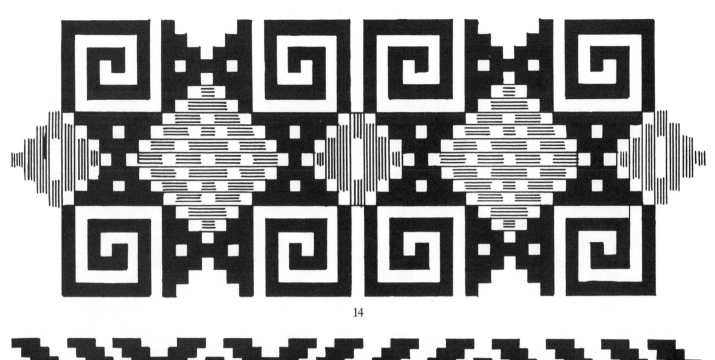

14

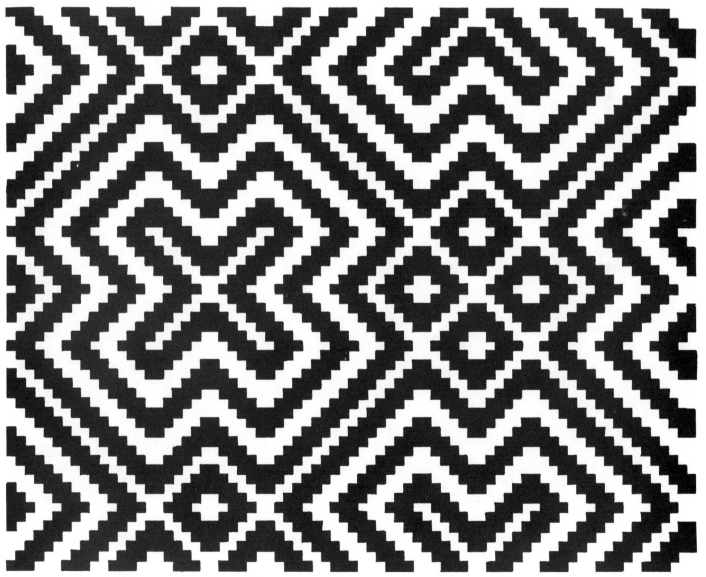

15

HUICHOL. 14: Row of diamonds with serrated units and angular spirals. Man's cape.
15: Allover pattern of diamond and cross-within-cross motifs; bilateral arrangement.
Small pouch.

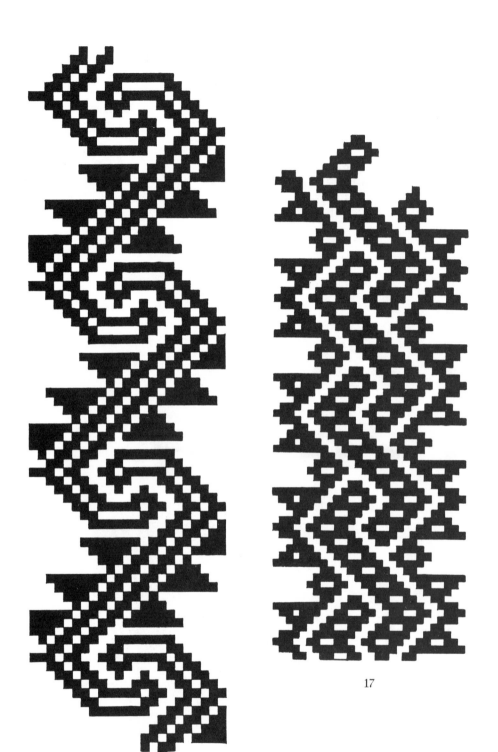

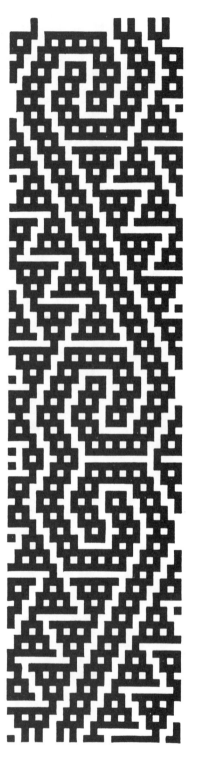

16

17

18

HUICHOL. 16: Interlocking S-units with serrated edges. Woman's shoulder cape.
17: Variant of interlocking S or cord motif with serrated edges. Woman's shoulder cape.
8 18: Variant of interlocking S-motif with diagonal serrated edging units. Woman's sash.

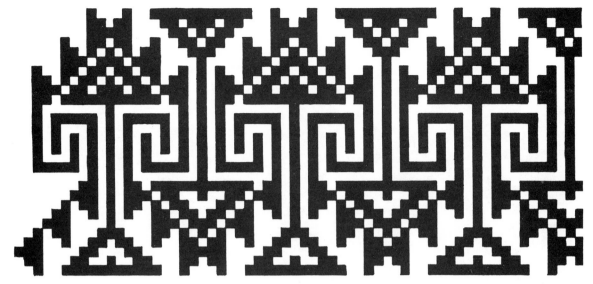

19

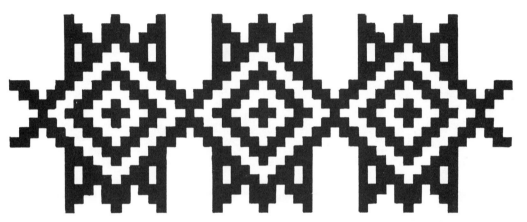

20

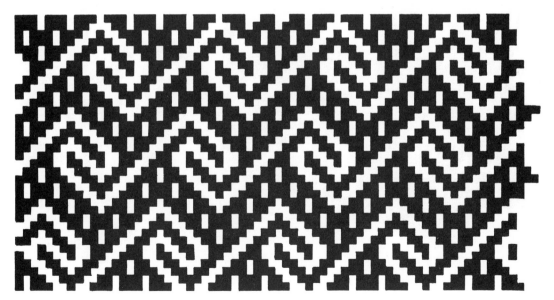

21

HUICHOL. 19: Interlocking arrow motifs with serrated edges and hook ends. Woman's shoulder cape. 20: Series of diamond-within-diamond units with serrated edges. Woman's shoulder cape. 21: Variation of stepped-fret motif; allover interlocking design. Small pouch.

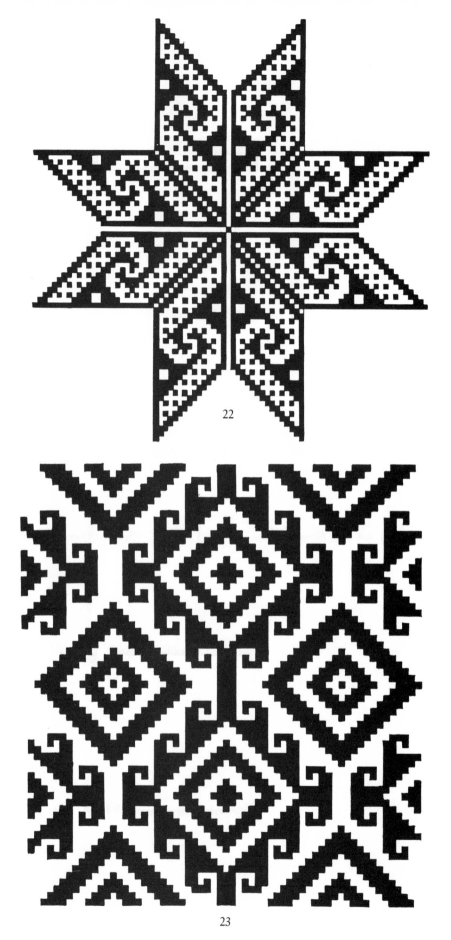

HUICHOL. 22: Large 8-pointed star (flower?) with interlocking scepter-like motifs.
Woman's shoulder cape. 23: Row of diamonds, alternating with row of diamond-with-
hooks. Neckpiece from a woman's shirt.

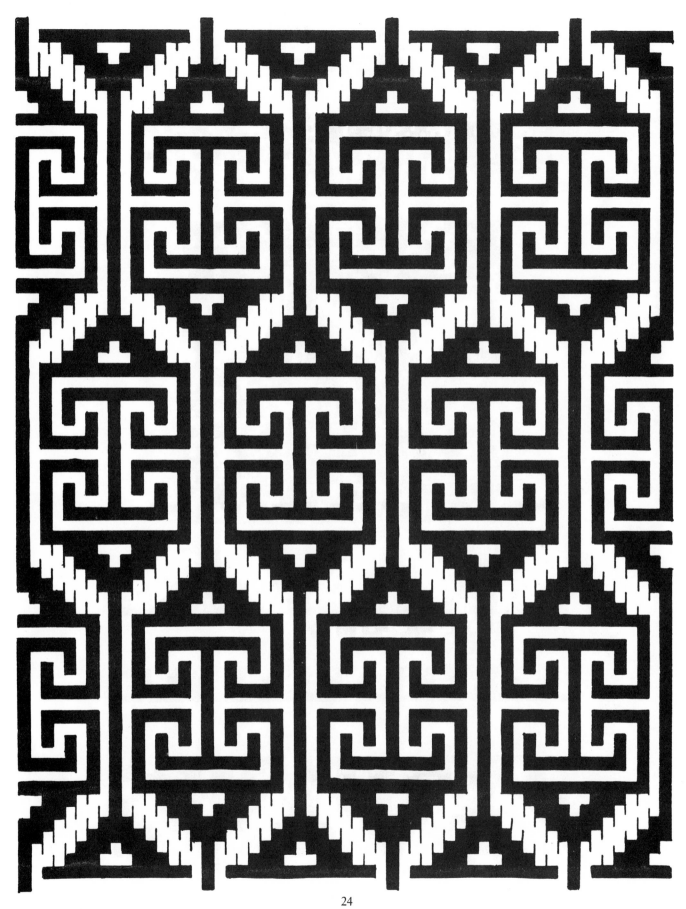

24

HUICHOL. 24: Allover pattern of hexagons with interlocking arrow units, vertically connected. Square cloth used for covering food or for ceremonial purposes. 11

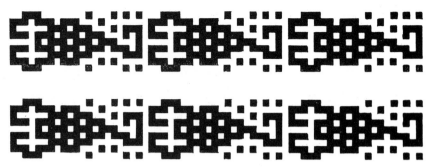

25

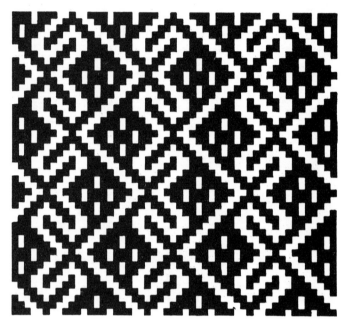

26

27

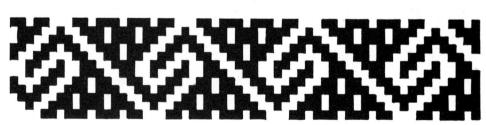

28

HUICHOL. 25: Stylized scorpions. Narrow band. 26: Allover stepped-fret motif pattern.
Small pouch. 27: Decorative stripe of stepped triangles. Woman's shoulder cape.
28: Variant of interlocking stepped-fret motif. Man's trousers.

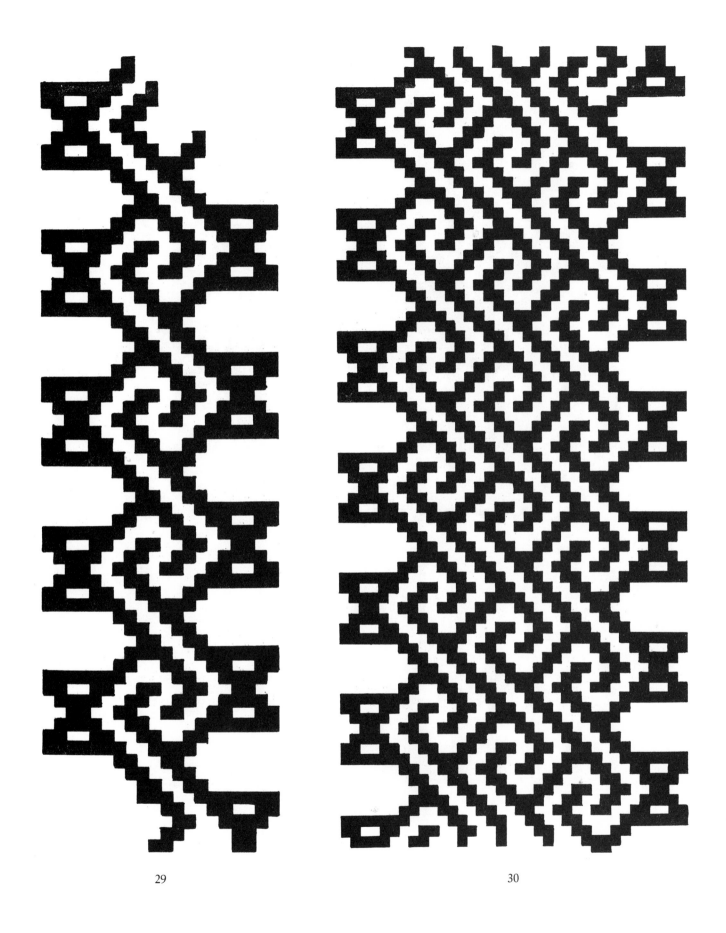

29

30

HUICHOL. 29: Interlocking spiral motif with serrated units at sides. Woman's shoulder
cape. 30: Allover pattern of interlocking and serrated spiral units. Man's cape.

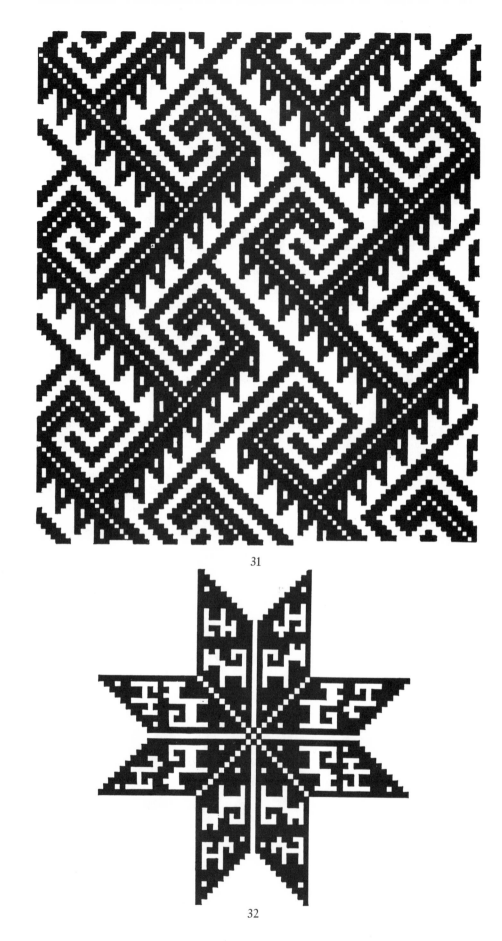

31

32

HUICHOL. 31: Allover pattern of interlocking hooks with serrated edges. Bag.
32: Series of 8-pointed stars (flowers?) with each section showing a pair of dog motifs.
Woman's shoulder cape.

14

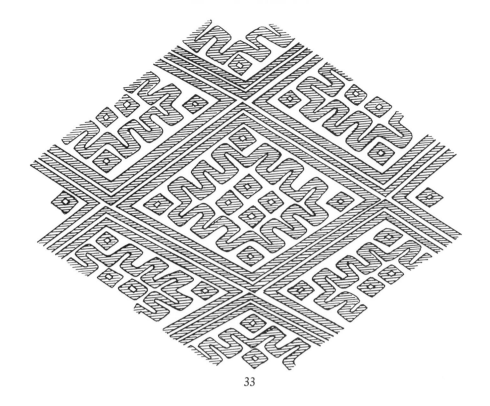

33

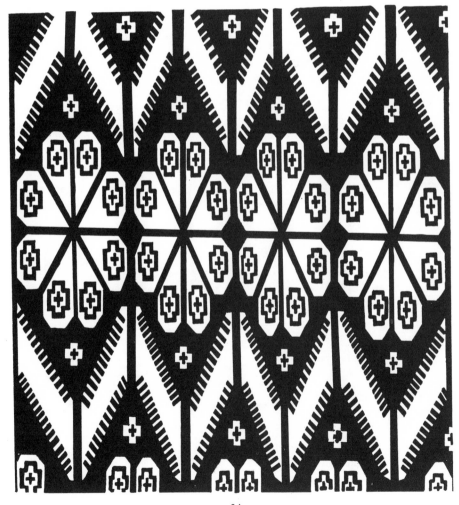

34

OTOMÍ. 33: Allover diamond-within-diamond pattern. Bag. 34: Allover pattern of zigzags with serrated edges, which alternate with rows of stylized flowers having small crosses in each petal. Bag.

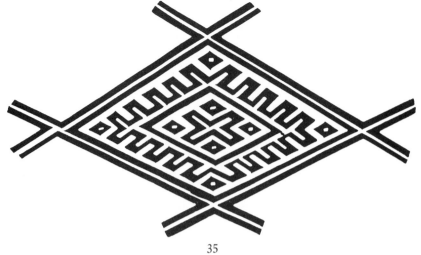

35

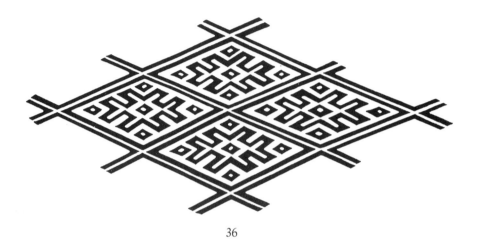

36

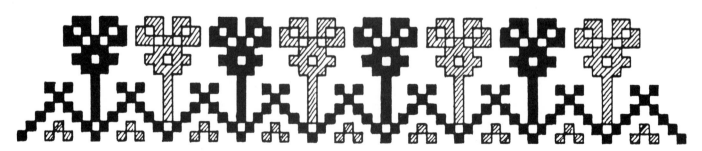

37

OTOMÍ. 35: Allover diamond pattern enclosing smaller diamonds with serrated borders.
Bag. 36: Allover diamond pattern; variant of 35. Bag. 37: Alternating light and dark
flowers forming border. Woman's shoulder cape.

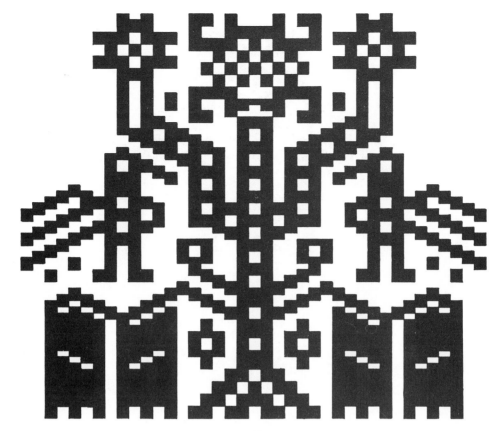

38

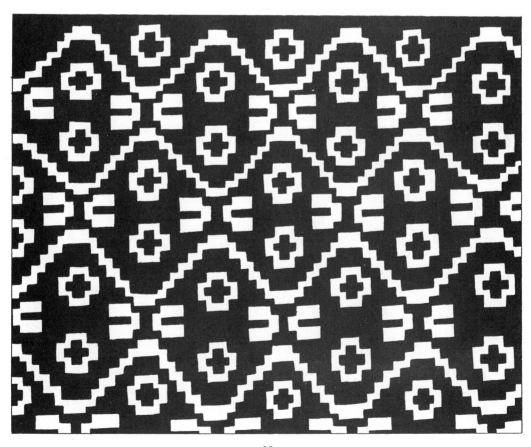

39

OTOMÍ. 38: Bilateral arrangement of birds and plant motif. Sash. 39: Allover diamond pattern composed of serrated zigzag lines, with paired crosses and geometric units inside diamond-shaped areas. Bag.

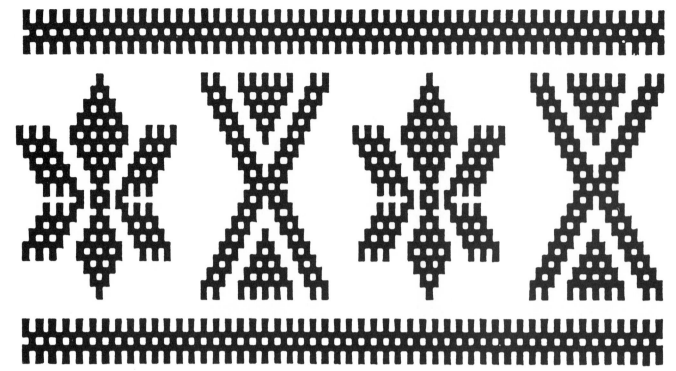

40

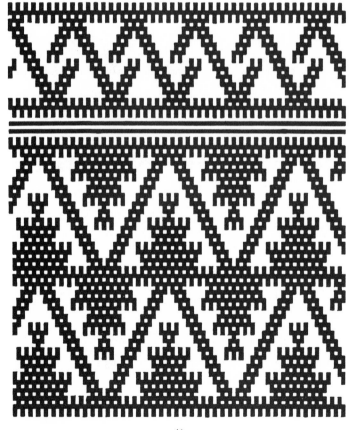

41

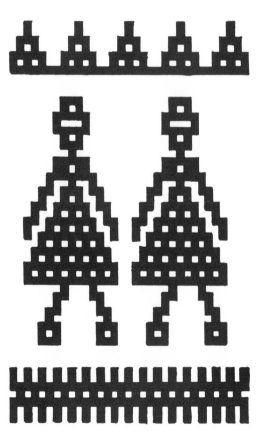

42

OTOMÍ. 40: Alternating motifs of stylized flowers and X-shaped units. Bag. 41: Upper
border exhibits Z-twist pattern with cross stripes; main pattern is an allover design of
zigzags with serrated triangles at upper and lower apices. Bag. 42: Doll figures within
horizontal rows of triangles and stripes. Bag.

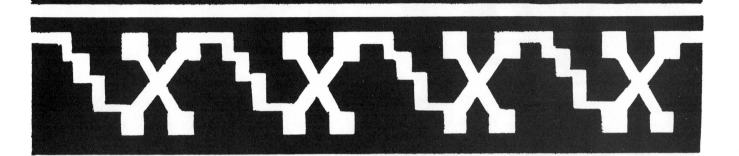

43

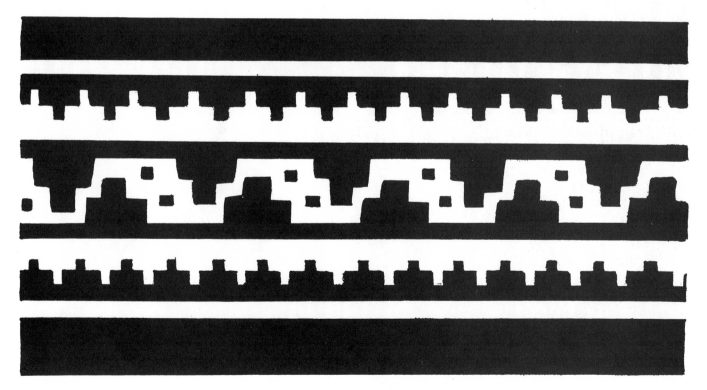

44

OTOMÍ. 43: Border of stepped zigzags. Bag. 44: Border of stripes, stepped lines and zigzags. Bag.

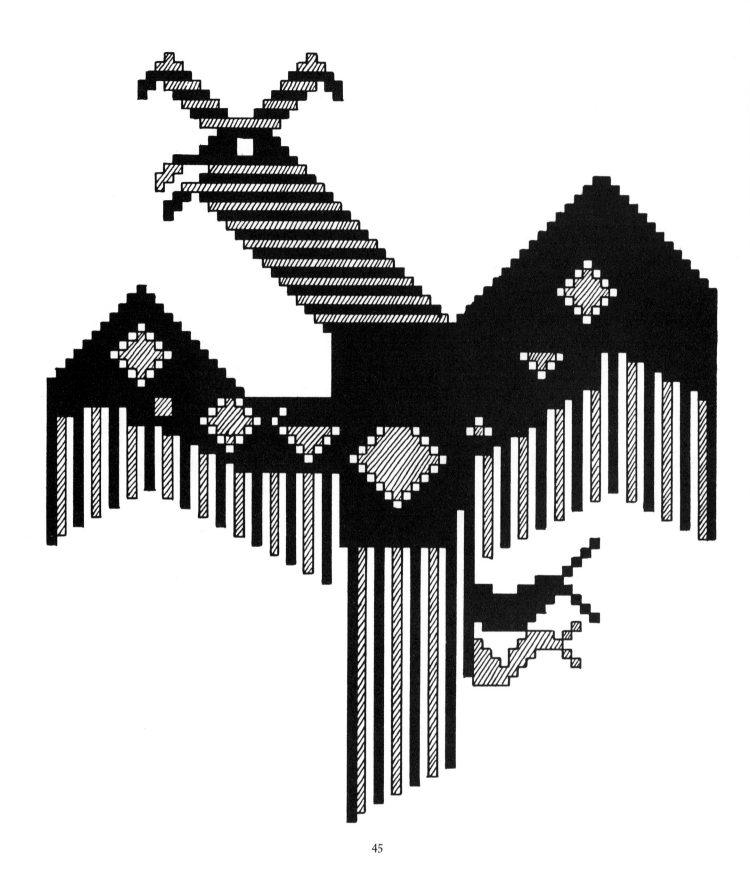

45

Otomí. 45: Large stylized eagle. Woman's shoulder cape.

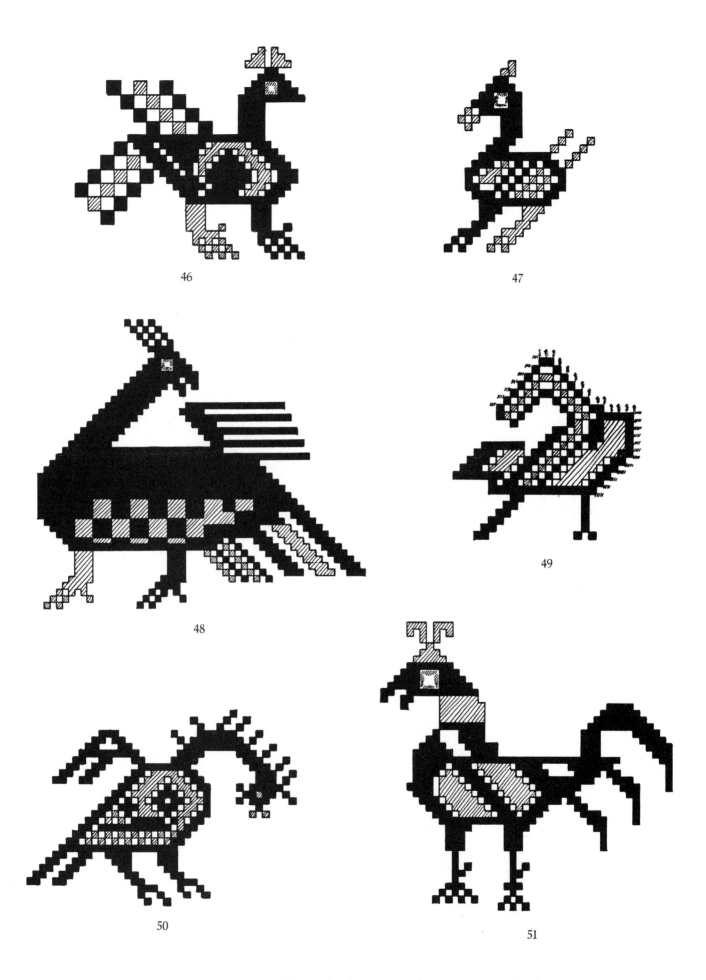

46

47

48

49

50

51

OTOMÍ. 46–51: Various animal forms; birds, roosters, horse. Woman's shoulder cape.

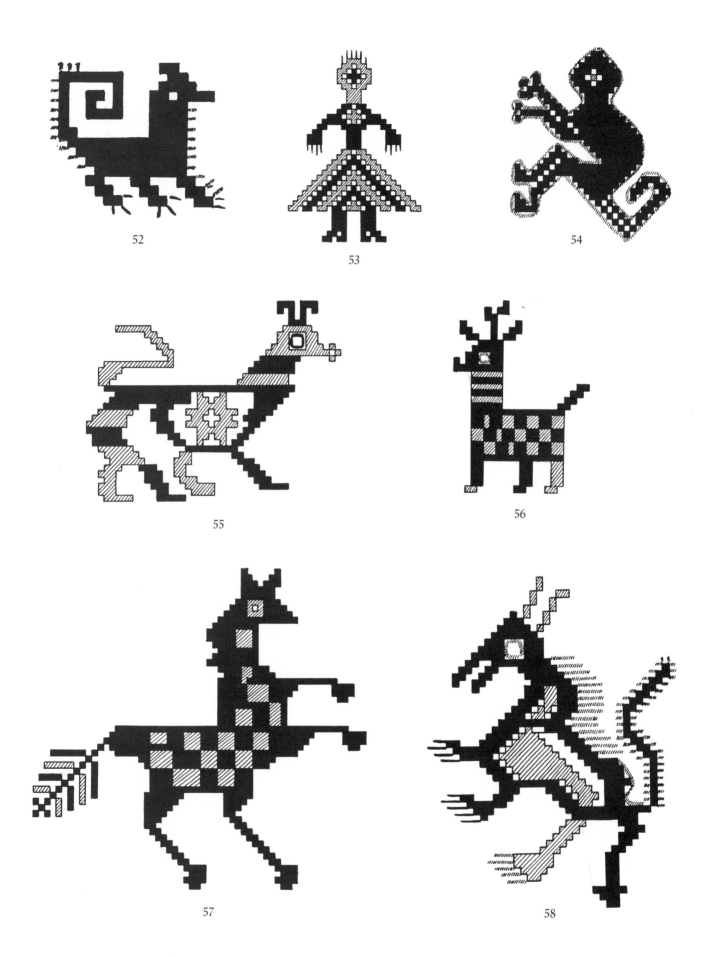

52

53

54

55

56

57

58

Отомí. 52–58: Various animal forms (dogs, monkey, horses, mule) and a doll figure.
Woman's shoulder cape.

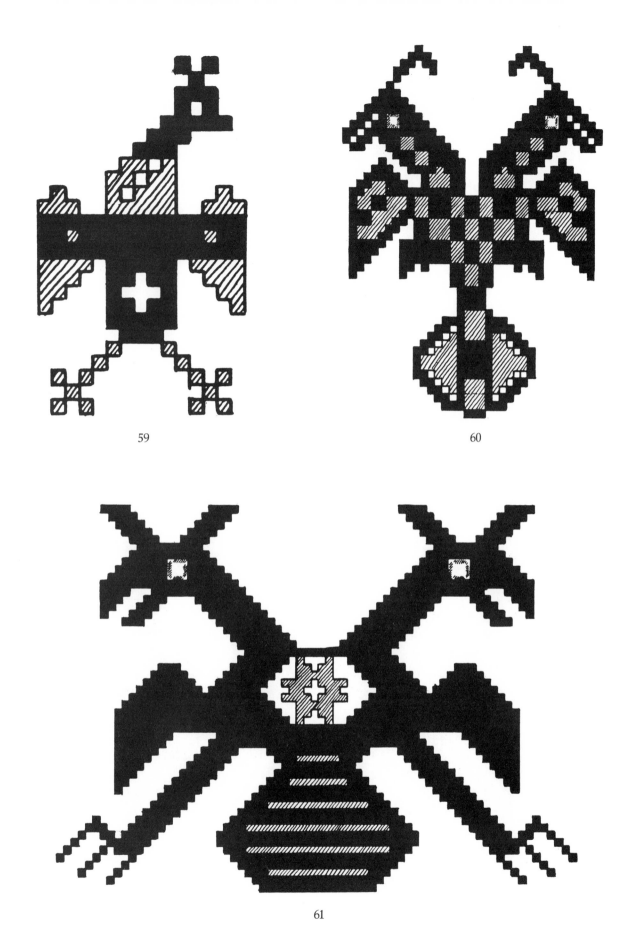

59

60

61

Oтomí. 59–61: Various birds, some double-headed. Woman's shoulder cape. 23

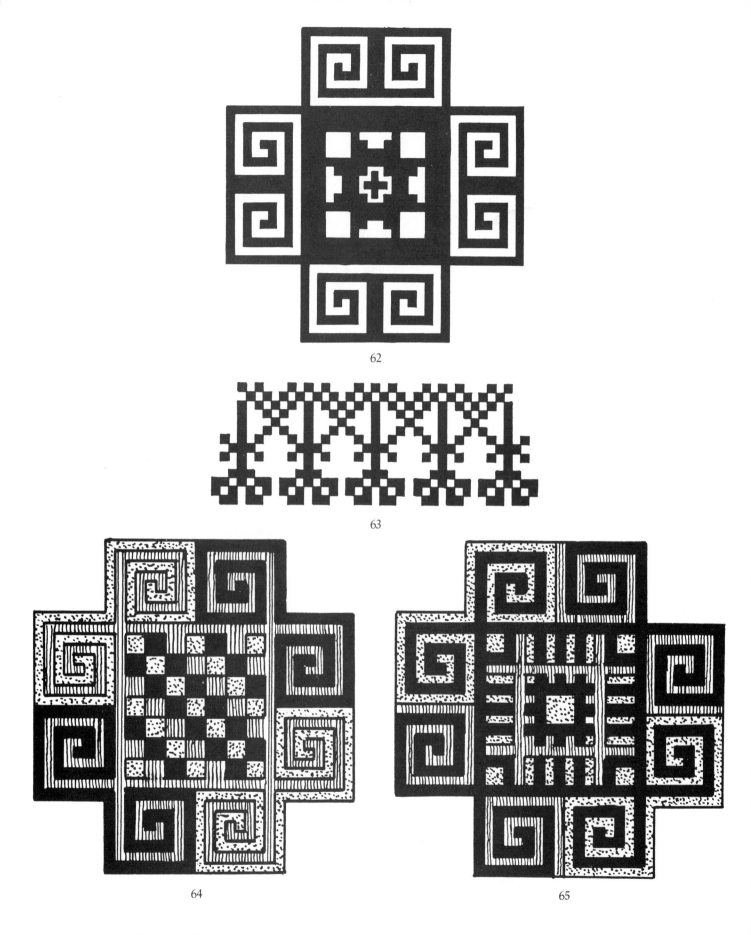

OTOMÍ. 62: Square shape with star and cross units. Woman's shoulder cape.
63: Border of stylized flowers. Woman's shoulder cape. 64, 65: Variants of square
motifs, bordered by angular scrolls and having centers of checkered or lattice-like design.
Rare old shoulder cape.

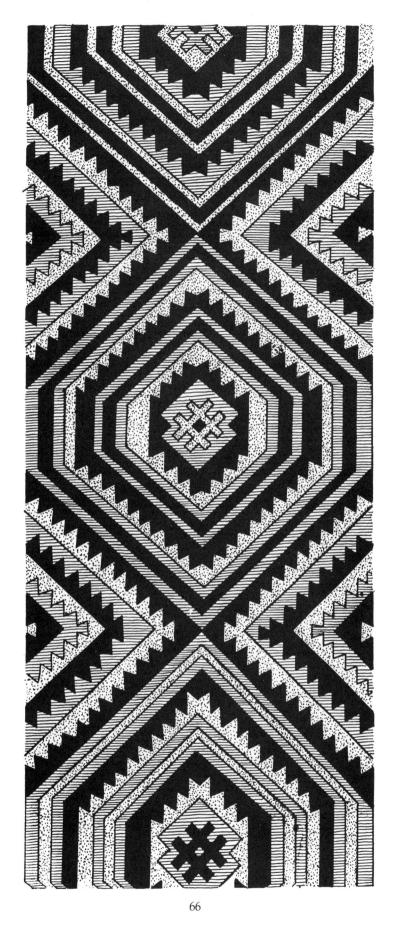

66

Oтомí. 66: Ornate border pattern of hexagon-within-hexagon motifs, some with serrated edges and with criss-cross units in center. Rare woman's shoulder cape.

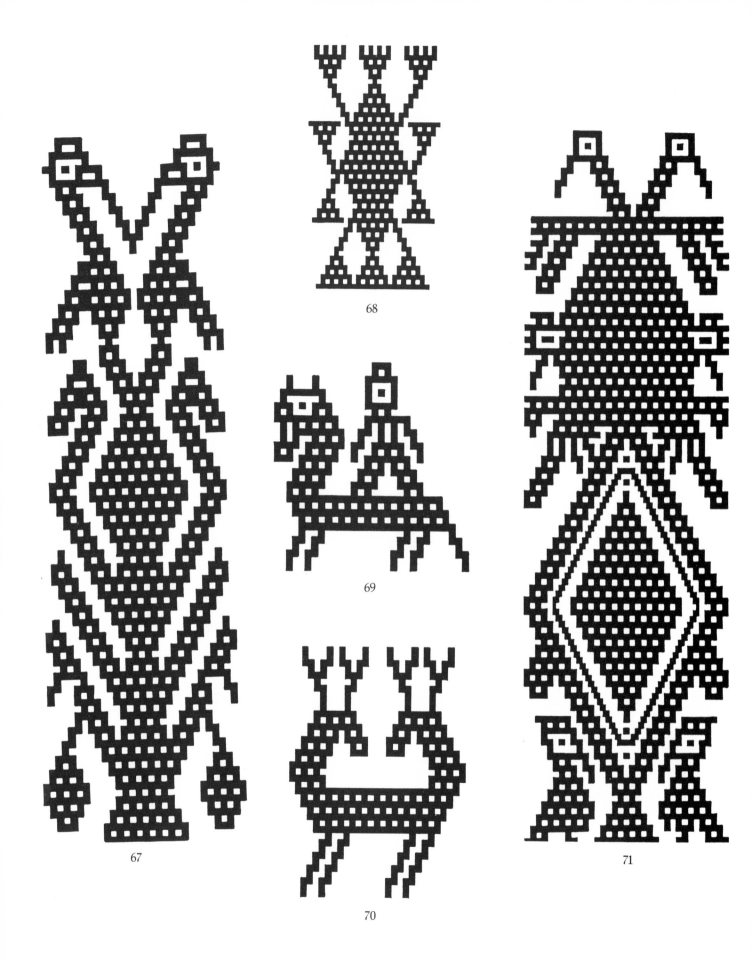

67 68 69 70 71

OTOMÍ. 67–71: Stylized bird, animal and plant motifs. From fine bands for braids and man's sashes.

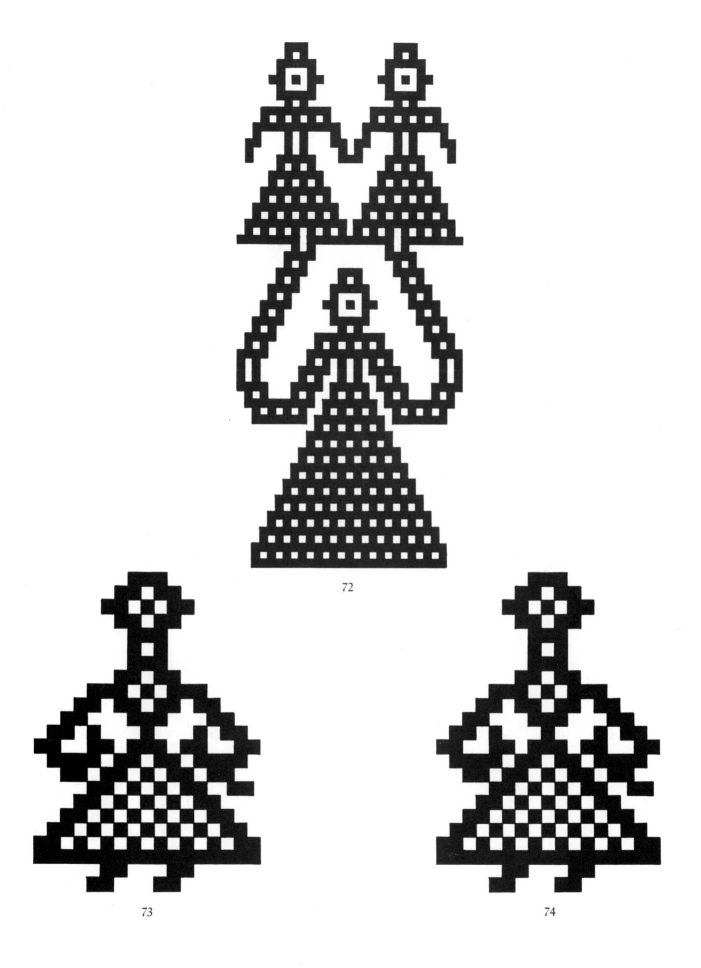

72

73

74

OTOMÍ. 72–74: Stylized doll figures. Sashes.

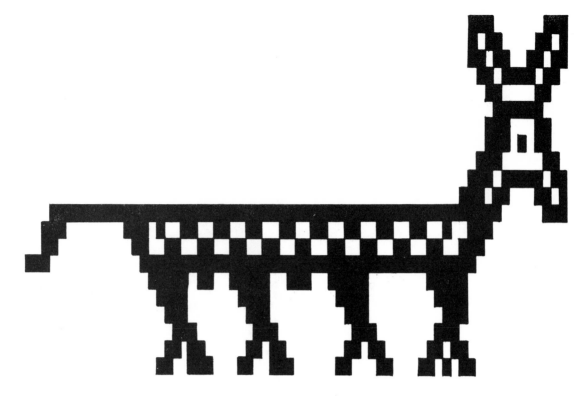

75

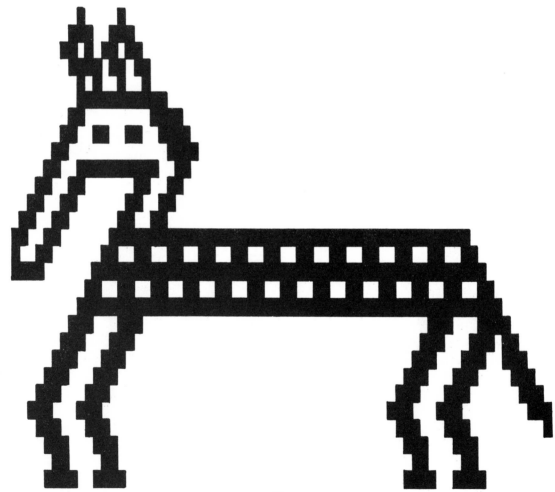

76

28 OTOMÍ. 75, 76: Variants of stylized animals (donkeys?). Woman's sash.

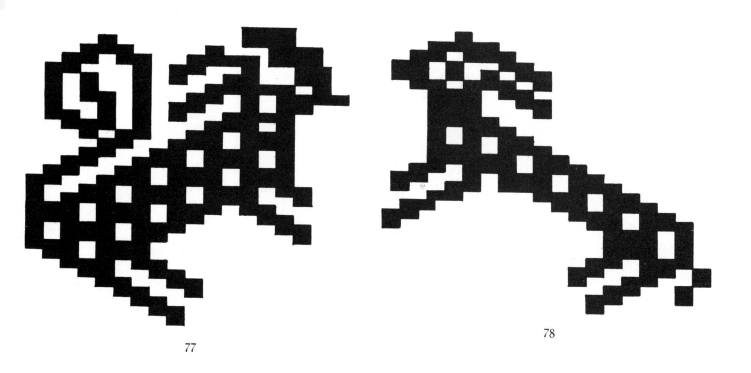

77

78

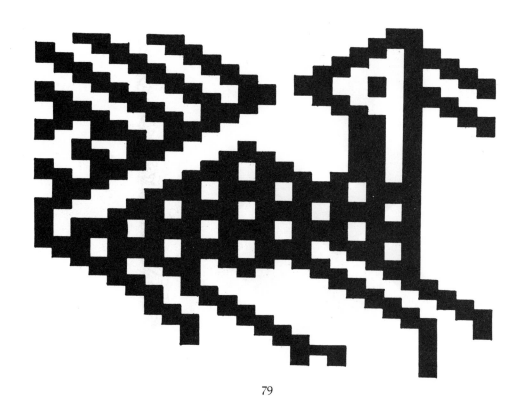

79

Oтоmí. 77–79: Various animal forms. Woman's sash. 29

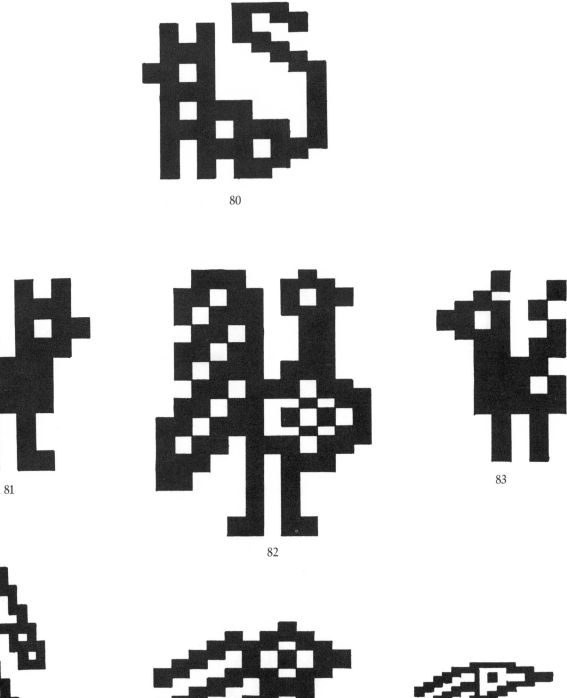

80

81

82

83

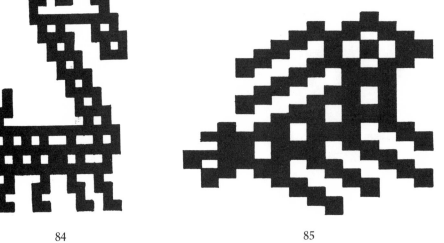

84

85

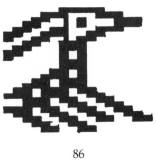

86

30 Oтomí. 80–86: Various animal forms. From fine bands for braids and woman's sash.

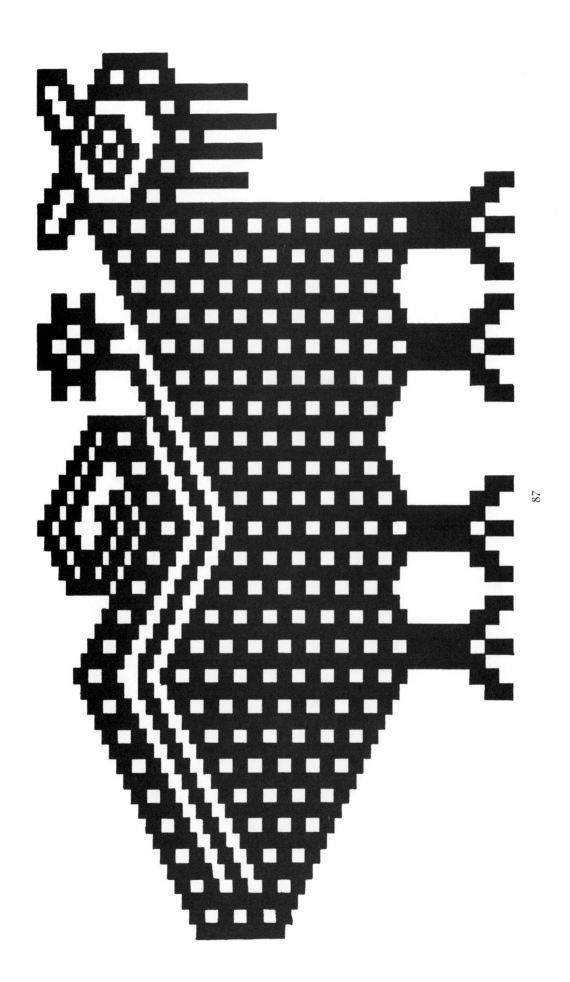

87

OTOMÍ. 87: Large bull, one of a pair facing each other. Woman's sash.

31

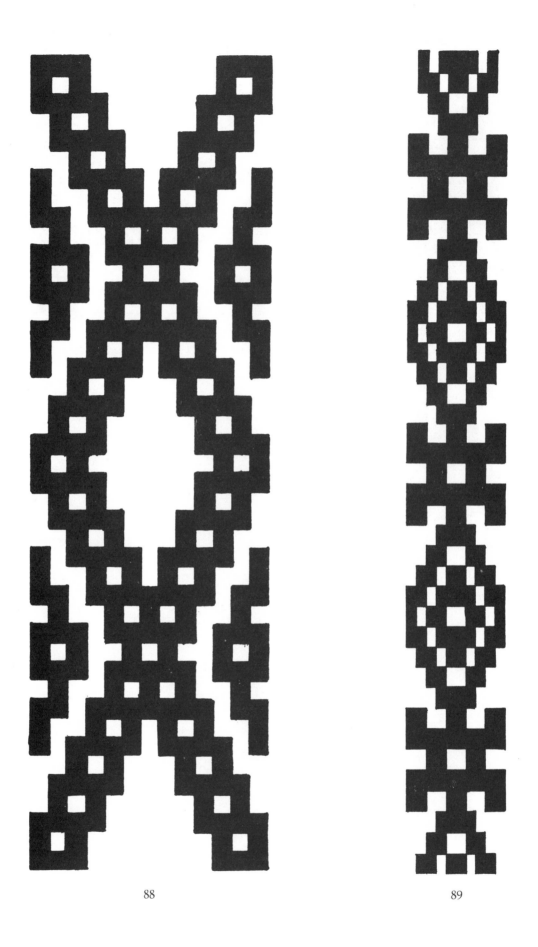

88

89

OTOMÍ. 88: Repeating geometric form of diamonds with serrated edges. Band for braids.
89: Narrow border of repeating geometric forms. Woman's sash.

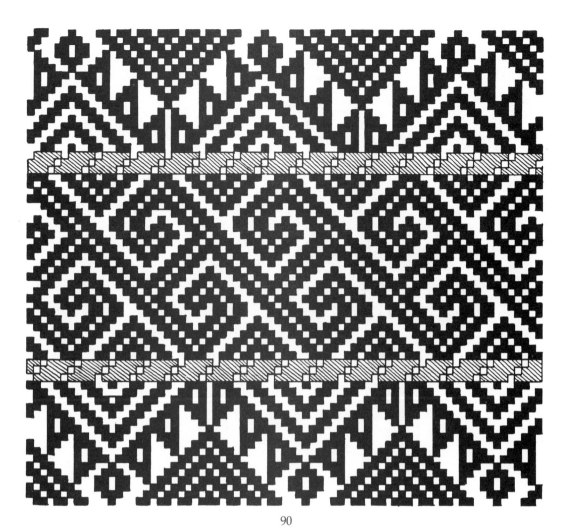

90

91

TEPEHUA. 90: Plain and serrated triangles and an allover pattern of interlocking frets.
Woman's shoulder cape. 91: Highly stylized leaf-and-flower motif. Rare old woman's
shoulder cape.

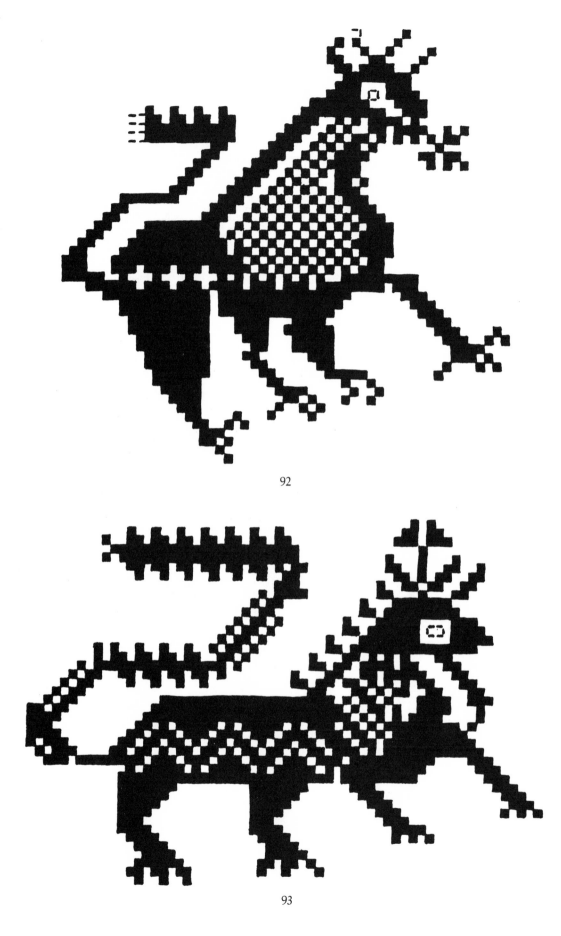

HUASTECO. 92, 93: Prancing animals with long bushy tails, decorated with flowers. Woman's shoulder cape.

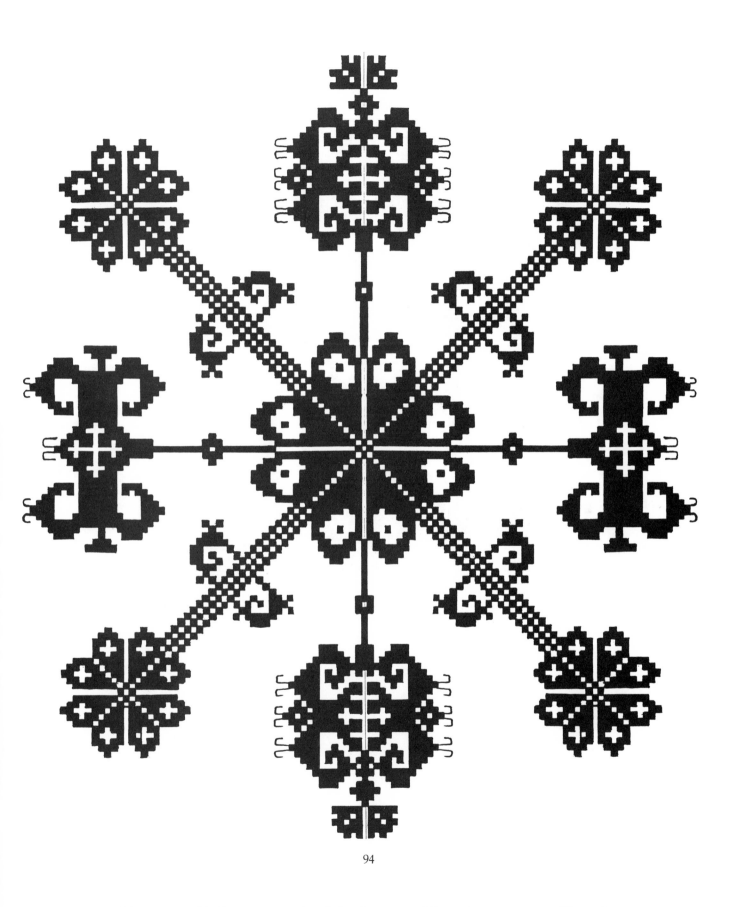

94

HUASTECO. 94: Large conventional floral pattern, bilateral arrangement. Woman's shoulder cape.

35

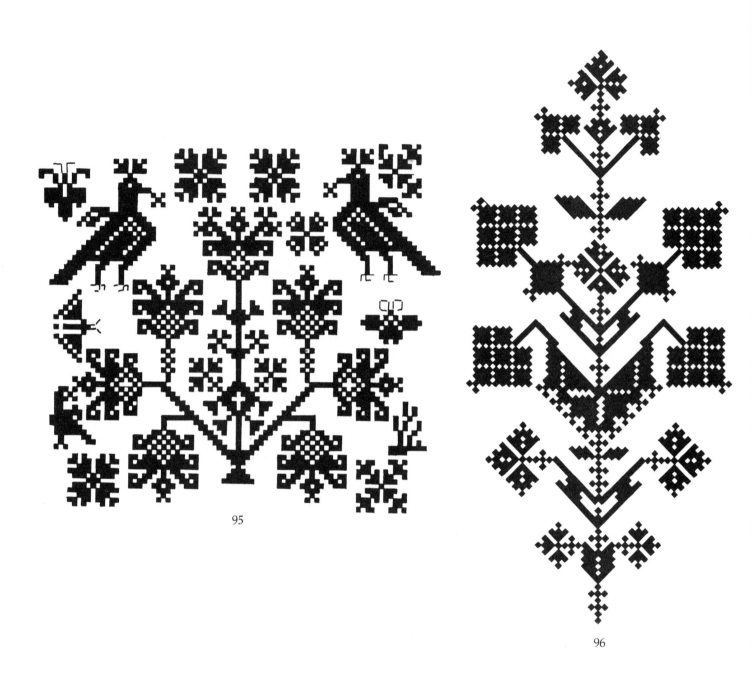

95

96

HUASTECO. 95: Conventionalized floral pattern with birds and butterflies. Bag.

96: Stylized floral pattern. Woman's shoulder cape.

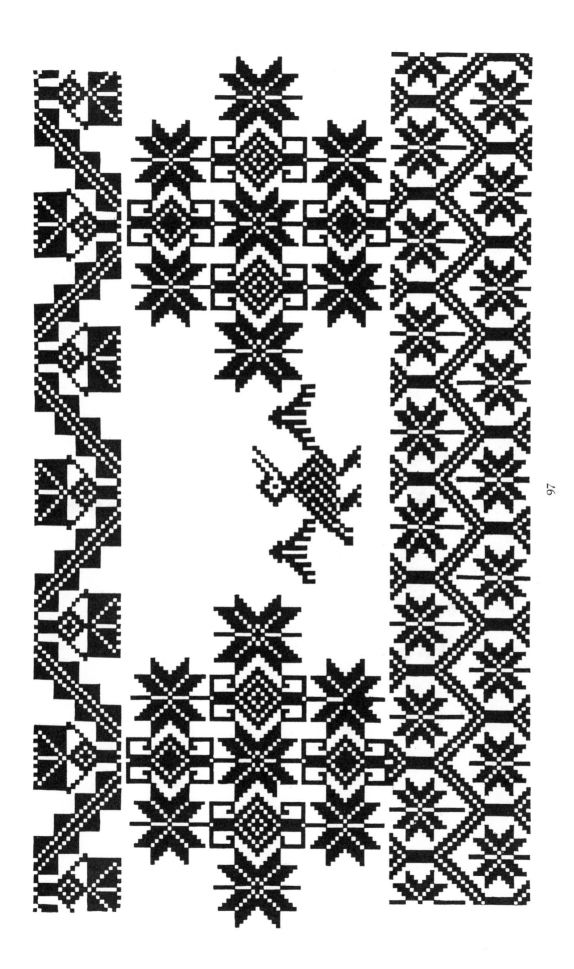

TLAPANECO. 97: Center panel exhibiting pattern of geometric floral and bird motifs. Old-style woman's tunic.

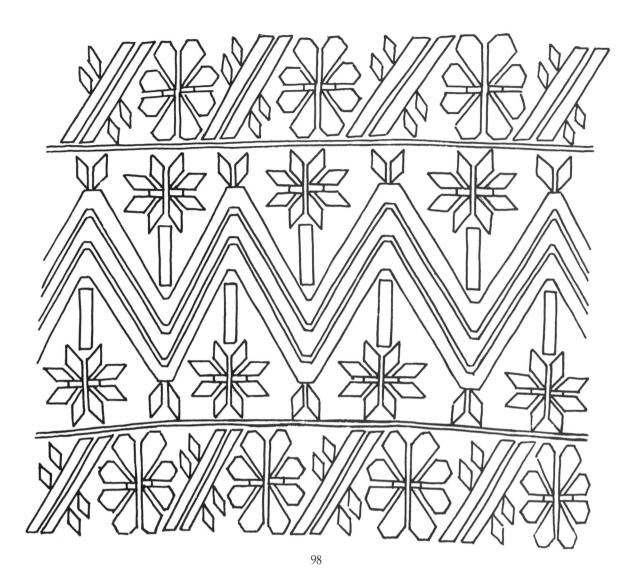

98

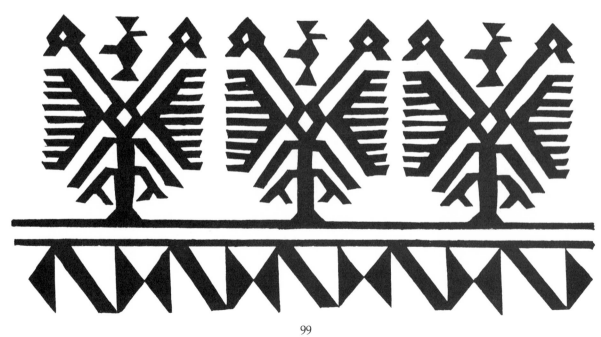

99

AMUZGO. 98: Flower motifs arranged within crossed bands. Woman's tunic.
99: Double-headed eagles, small birds and geometric units, arranged within crossed
bands. Woman's tunic.

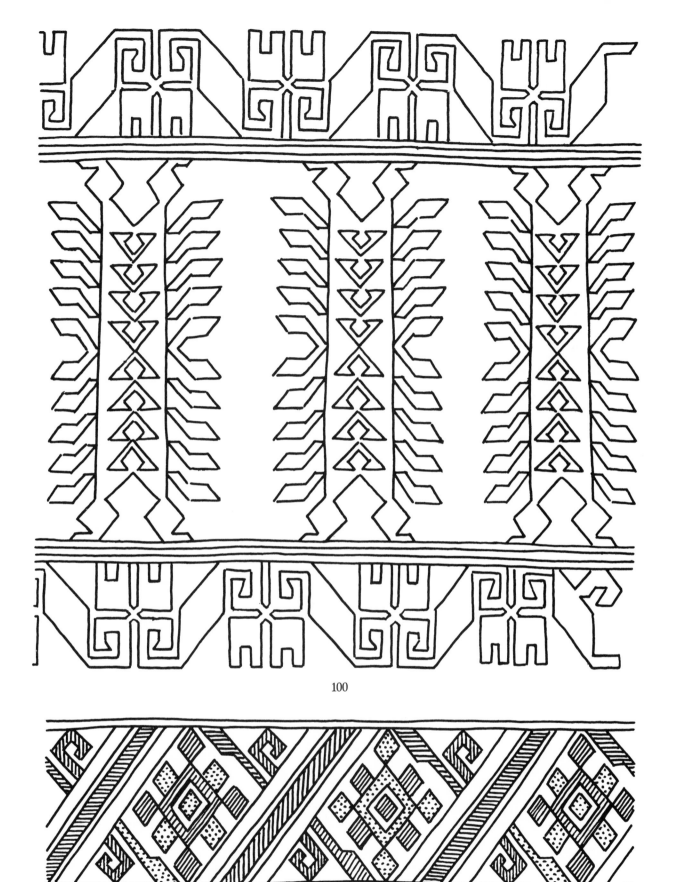

100

101

AMUZGO. 100, 101: Abstract design motifs arranged within crossed bands. Woman's tunic.

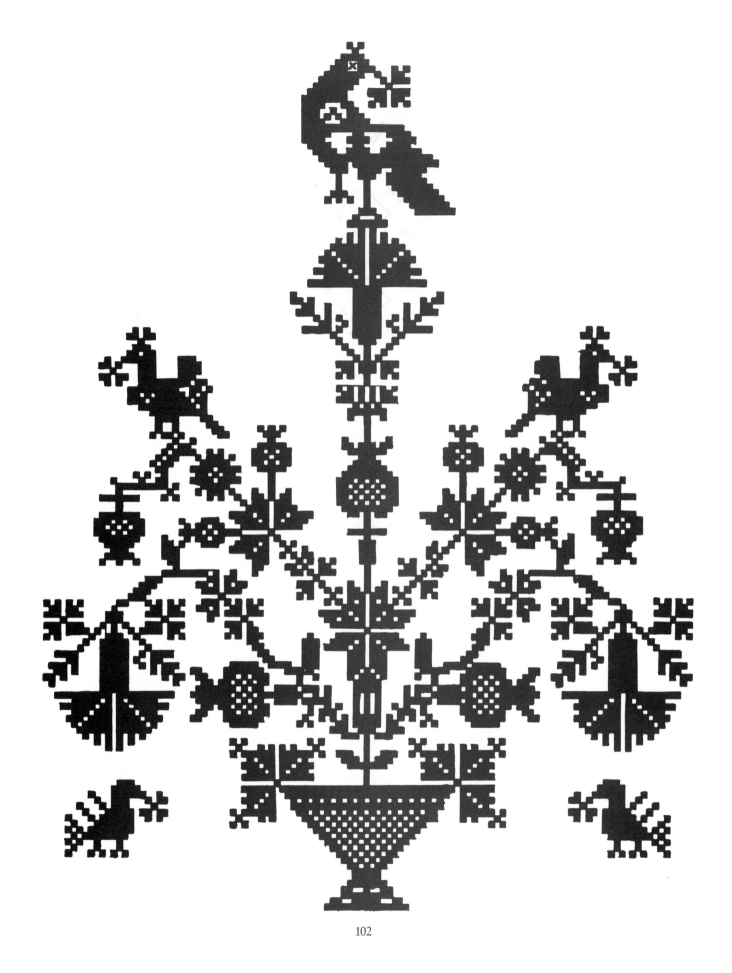

102

Mestizo. 102: Tree-of-Life design. Embroidery sampler.

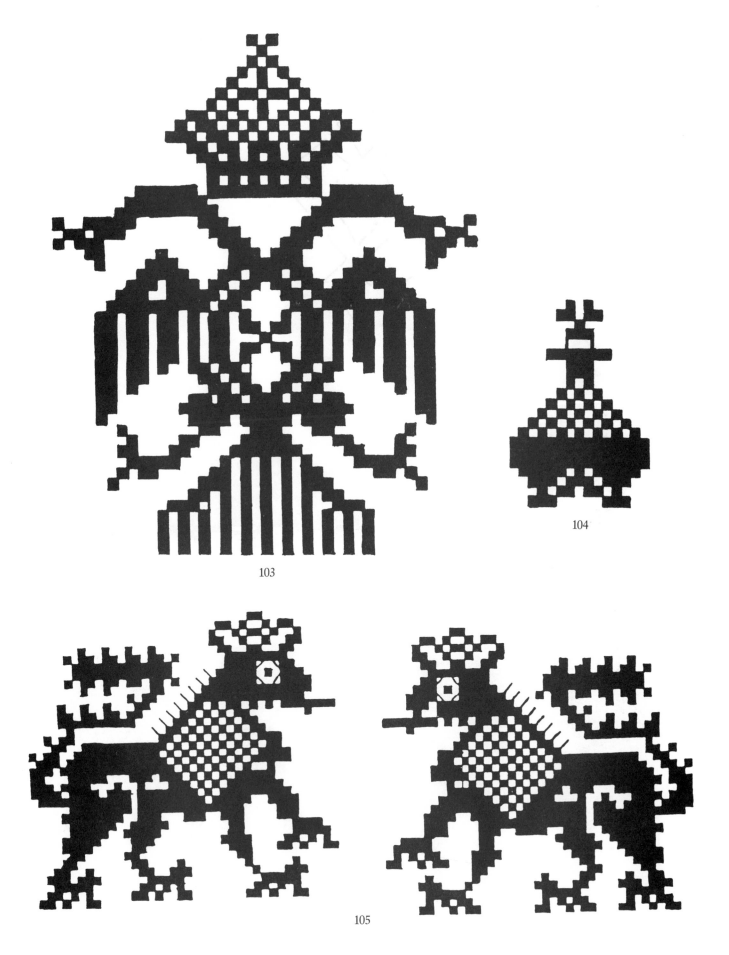

103

104

105

MESTIZO. 103–105: Double-headed eagle, crown and pair of crowned lions. Embroidery
sampler.

41

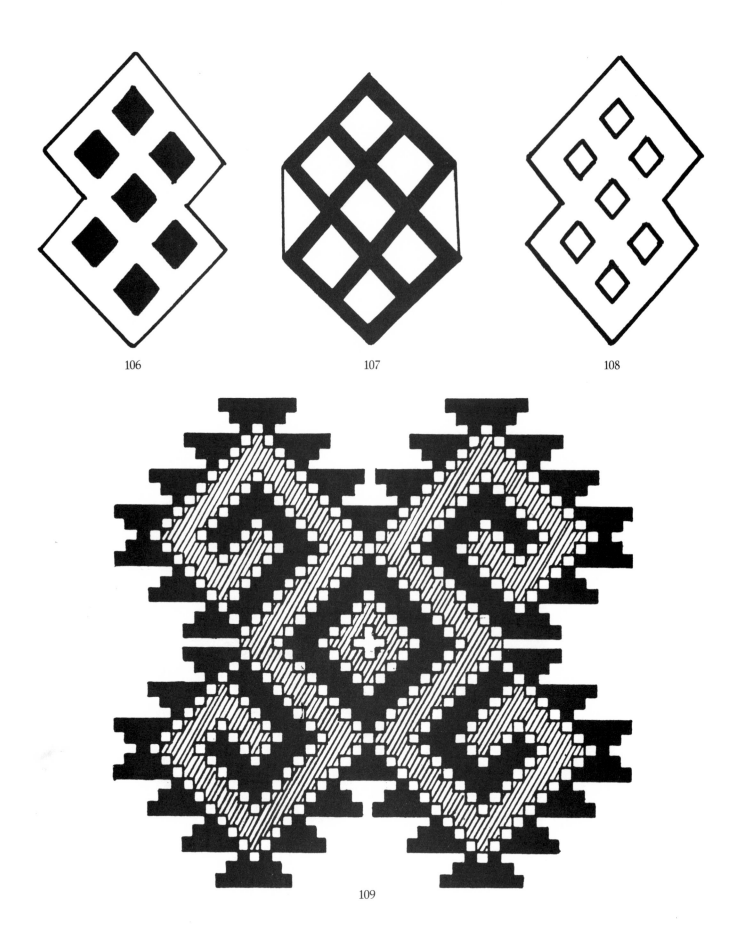

106 107 108

109

NAHUA. 106–108: Simple cross-bands motifs. Traditional neck-opening decoration on old-style woman's shoulder cape. 109: Conventionalized diamond-and-hooks motifs. Old-style woman's shoulder cape.

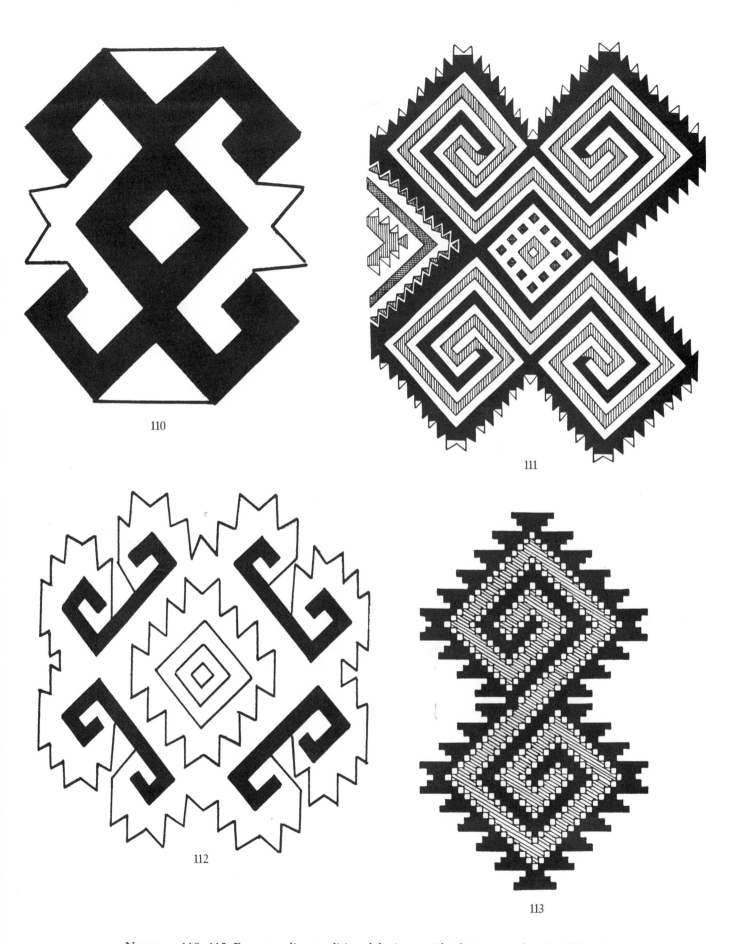

110

111

112

113

NAHUA. 110–112: Free-standing traditional design motif utilizing cross bands. Old-style woman's shoulder cape. 113: Conventionalized S-motif with serrated edge. Woman's shoulder cape.

114

115

NAHUA. 114, 115: Free-standing motifs utilizing cross-band designs in diamond arrangements. Old-style woman's shoulder cape.

44

116

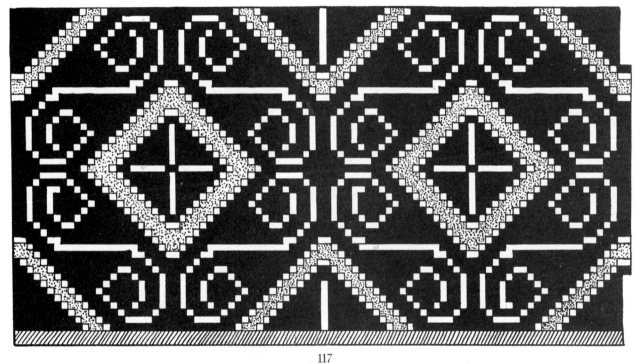

117

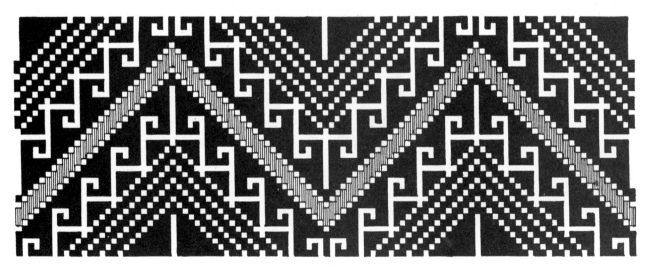

118

NAHUA. 116: Free-standing design with diamond motif. Old-style woman's shoulder cape. 117: Bilateral arrangements of diamonds, chevrons and S-units, paired and countered. Old-style skirt band. 118: Zigzag line enclosing chevrons with hooks along edge. Old-style skirt band.

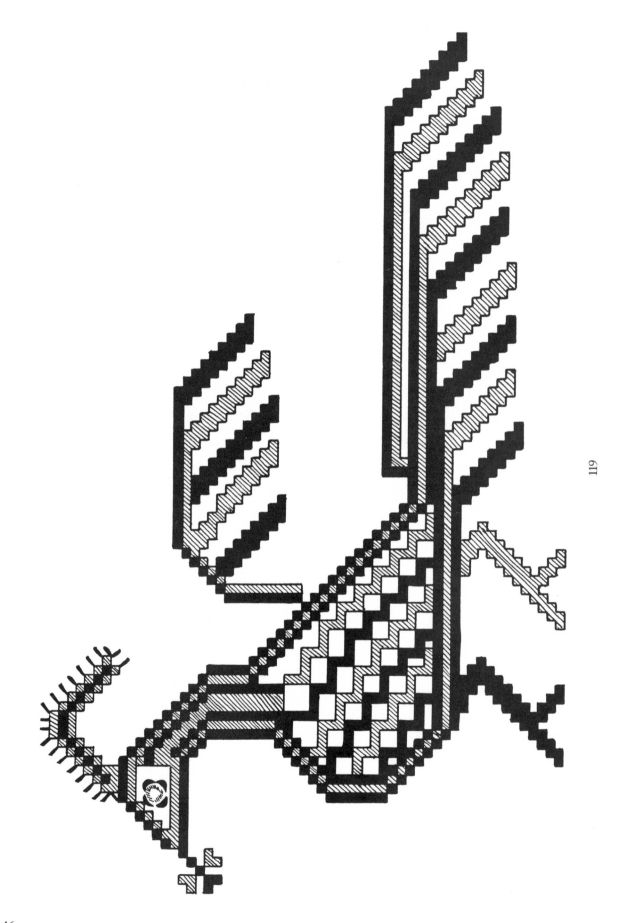

46

NAHUA. 119: Large free-standing bird with elaborate plumage, holding a flower in its beak. Old-style woman's shoulder cape.

119

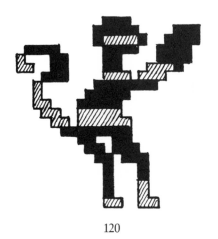

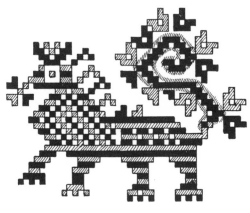

120

121

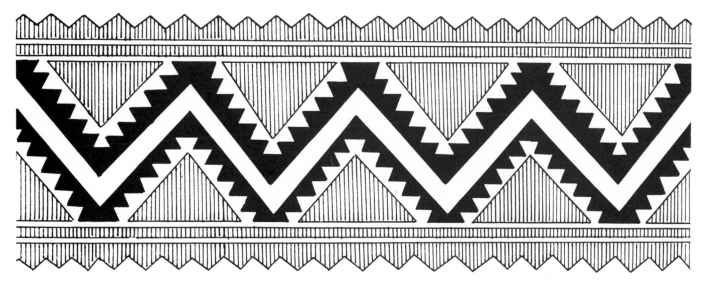

122

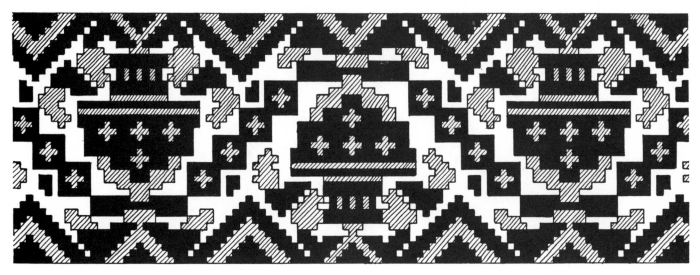

123

NAHUA. 120, 121: Free-standing animal motifs, the lion heavily decorated with a floral motif. Old-style skirt band. 122: Geometric border of serrated zigzags, triangles and narrow cross stripes. Old-style woman's shoulder cape. 123: Vine motif composed of stepped squares and highly stylized floral elements. Woman's shoulder cape.

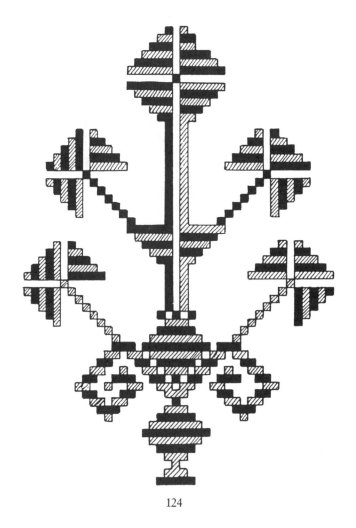

124

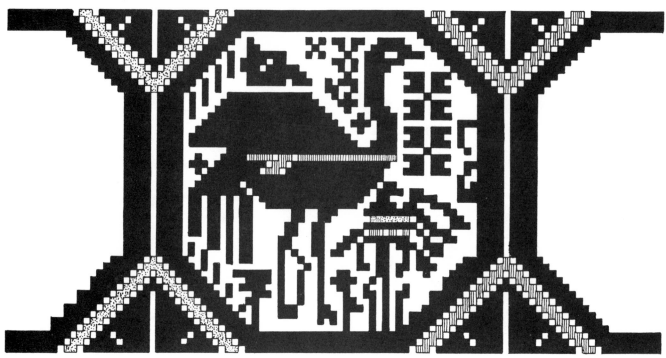

125

NAHUA. 124: Flower and plant motif, emerging from a vase. Woman's shoulder cape.
125: Border pattern of octagonal frames containing a large turkey, a smaller bird and
various geometric and floral motifs. Skirt band.

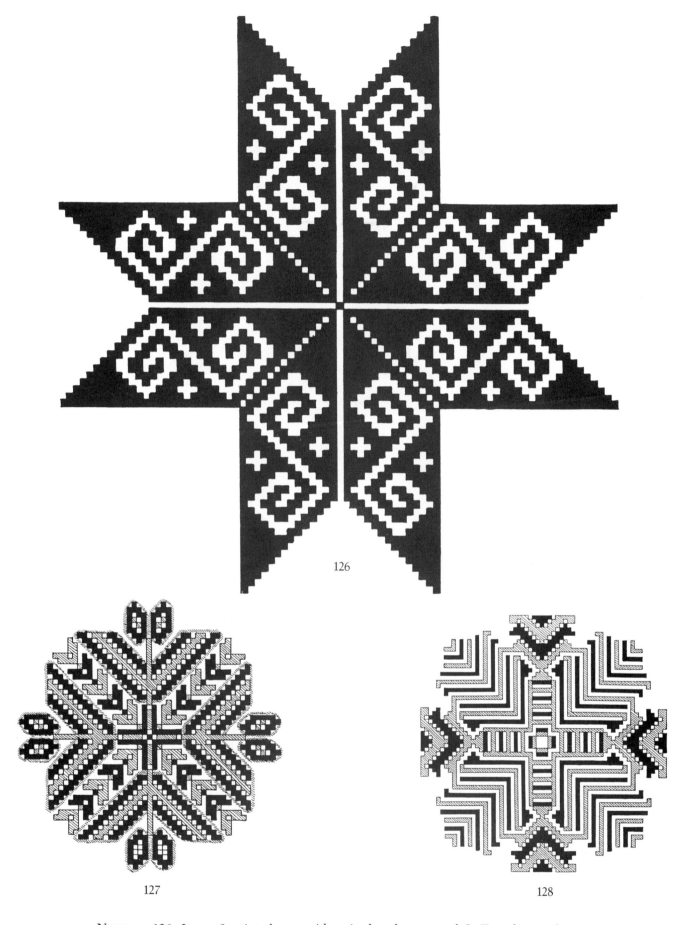

126

127 128

NAHUA. 126: Large 8-pointed star with paired and countered S, Z and cross forms
within each quadrant. Old-style woman's shoulder cape. 127: Free-standing highly
stylized floral pattern. Old-style woman's shoulder cape. 128: Corner motif exhibiting
highly stylized flower-and-leaf pattern. Old-style woman's shoulder cape.

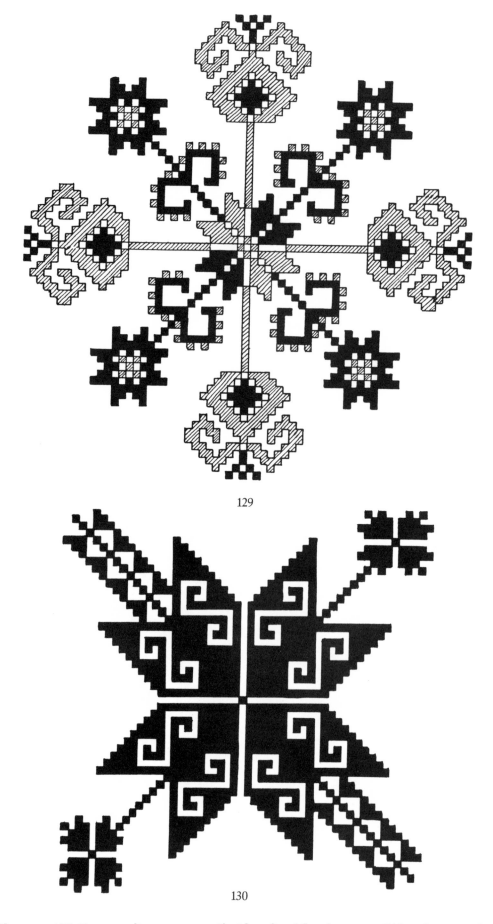

129

130

NAHUA. 129: Free-standing corner motif with stylized floral pattern. Old-style woman's shoulder cape. 130: Diagonal corner pattern of 8-pointed star having paired and countered S and Z-forms within sections; stylized floral motifs and geometric bands accentuate the diagonal arrangement. Woman's shoulder cape.

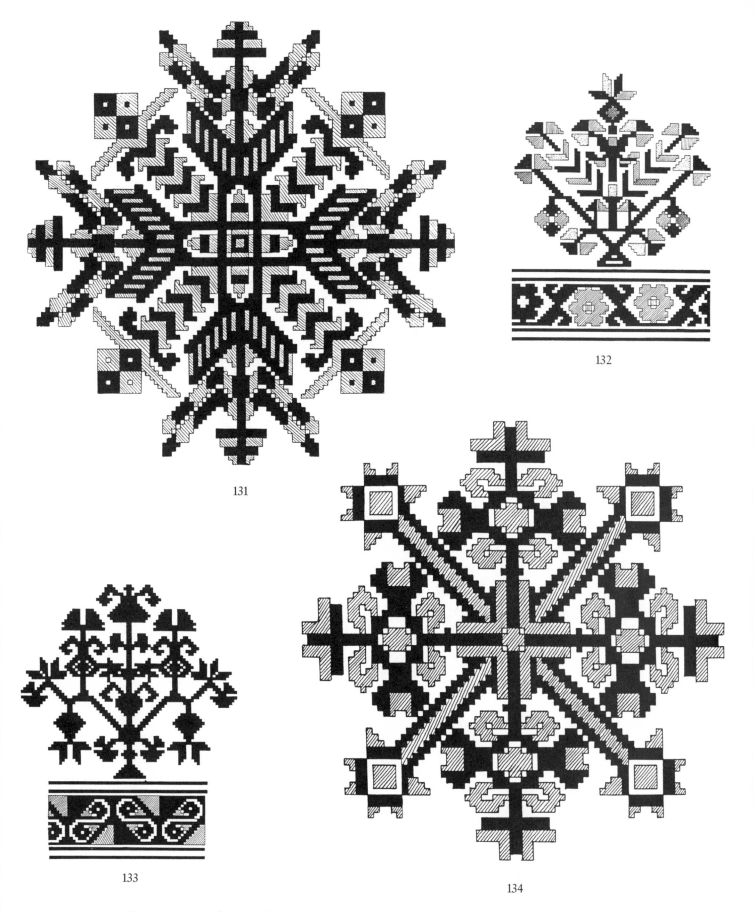

NAHUA. 131: Elaborately composed corner motif of floral pattern, bilaterally arranged. Old-style woman's shoulder cape. 132: Border pattern showing stylized vine and flower motif; above, a stylized Tree-of-Life motif. Skirt. 133: Lower border exhibits series of slanting S and Z-units; above, a Tree-of-Life motif. Skirt. 134: Corner motif exhibiting bilateral arrangement of stylized floral pattern. Old-style woman's shoulder cape.

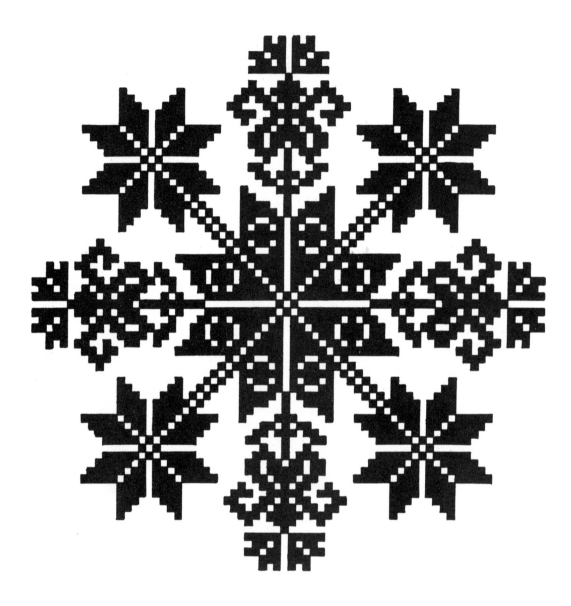

135

NAHUA. 135: Free-standing bilateral floral pattern with two borders, the upper showing countered step motifs, the lower composed of small cross elements arranged to form larger crosses in a repeating pattern. Old-style woman's shoulder cape.

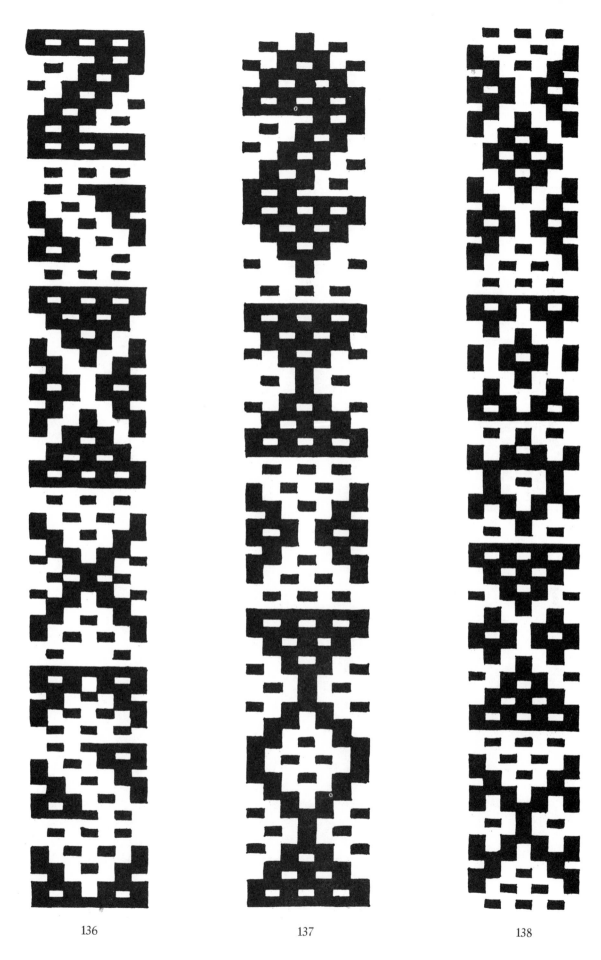

136 137 138

NAHUA. 136–138: Variants of repeating geometric patterns incorporating S, Z and X-motifs. Old-style headband.

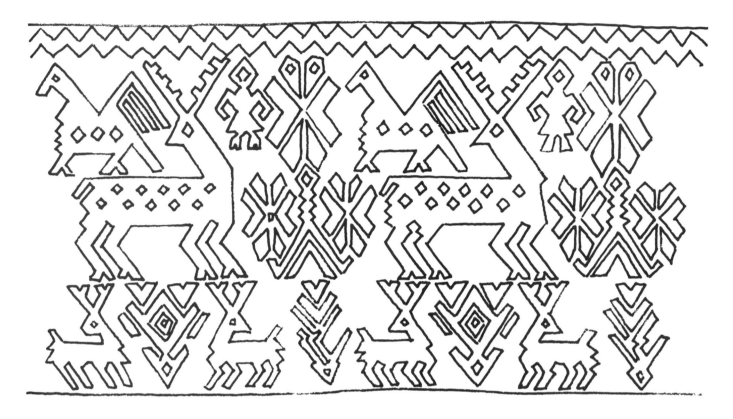

139

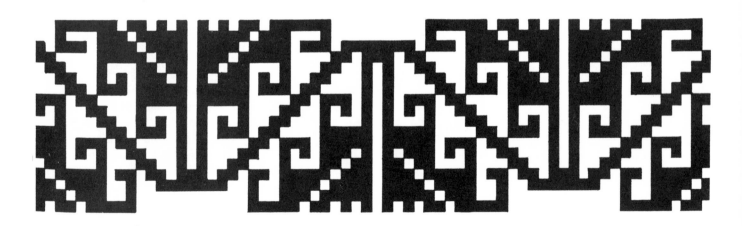

140

NAHUA. 139: Design showing deer, bird, human figure and floral elements. Woman's blouse. 140: Zigzag pattern with hooks and triangles. Bag.

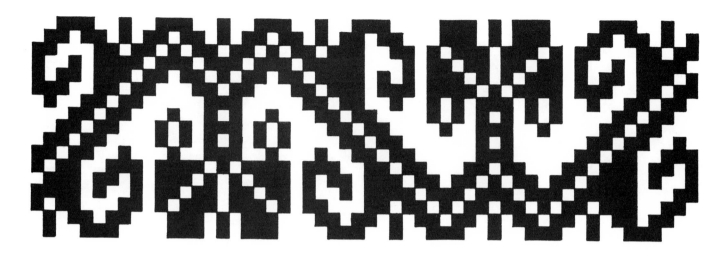

141

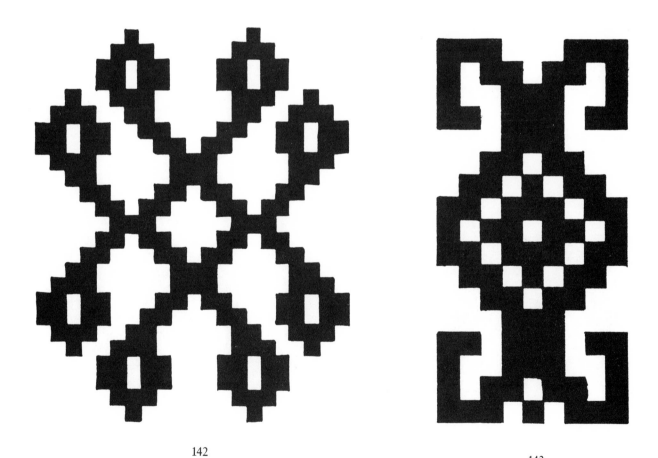

142

143

NAHUA. 141: Geometric vine motif with spirals and stylized flowers. Sash. 142: Diamond-and-hook motif. Sash. 143: Row of diamond-and-hook motifs. Woman's shoulder cape.

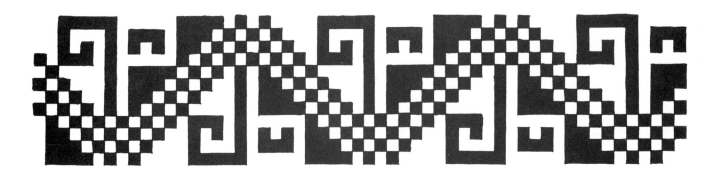

144

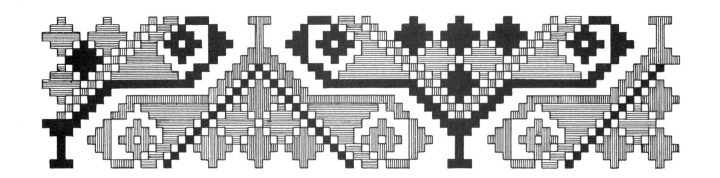

145

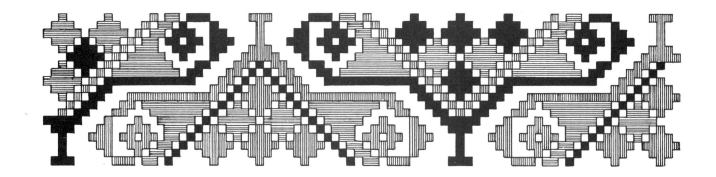

NAHUA. 144: Zigzag pattern with stepped-fret motif. Old-style headband. 145: Pair of
stylized vine motifs containing spiral elements. Woman's shoulder cape.

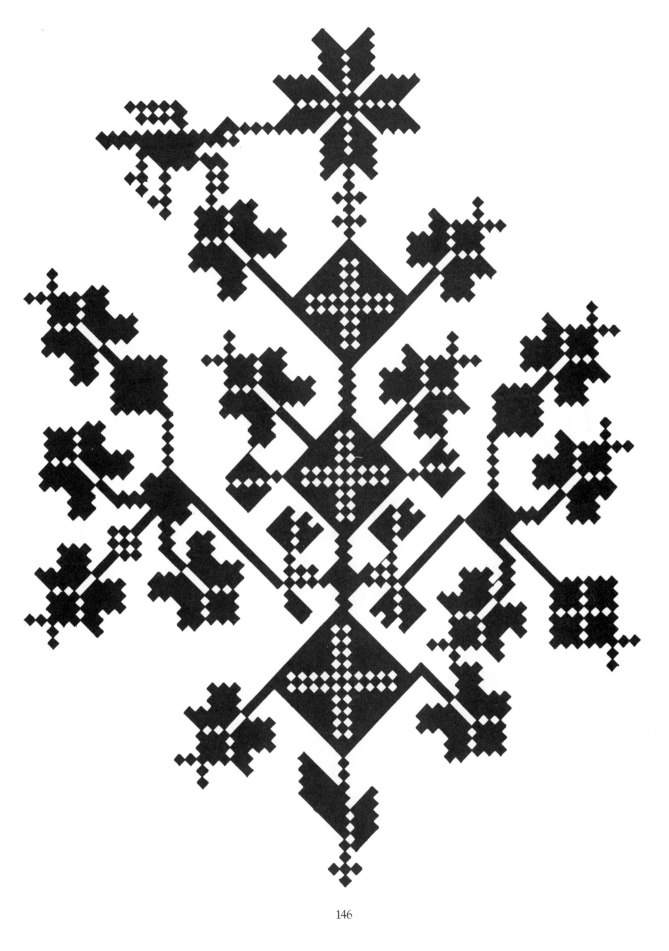

146

NAHUA. 146: Highly conventionalized floral and plant motif with hummingbird at top
left. Old-style long shawl.

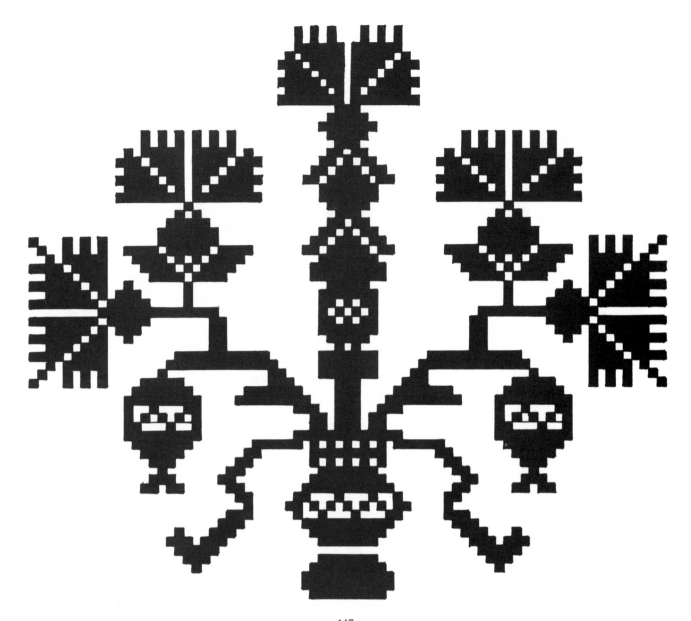

147

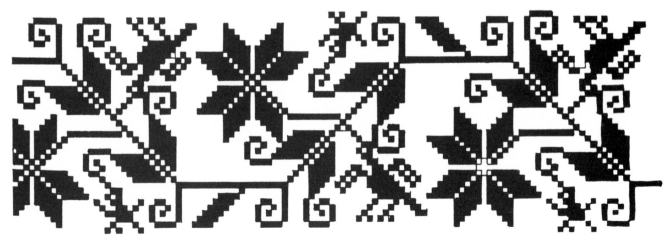

148

NAHUA. 147: Conventionalized plant, flower and fruit elements, growing from vase. Old-style long shawl. 148: Border design of vine with floral motifs interspersed with hummingbirds. Old-style long shawl.

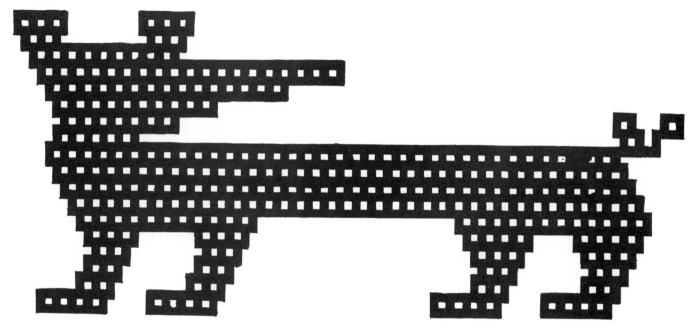

149

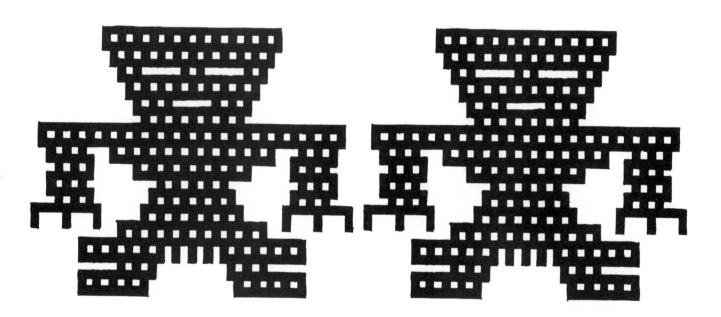

150

NAHUA. 149: Animal figure (dog?) with head turned backwards. Old-style sash.
150: Pair of human figures. Old-style sash.

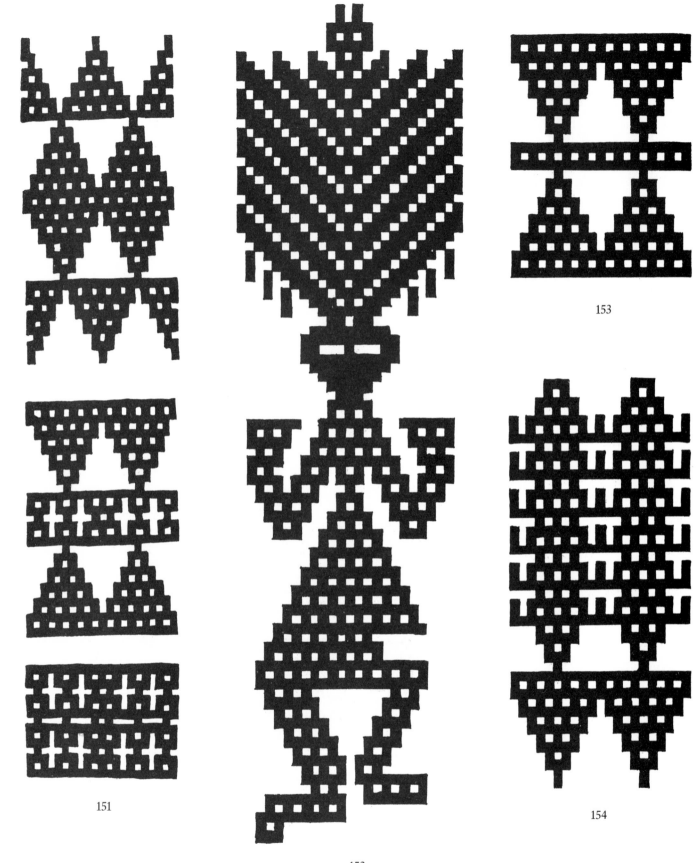

151 152 153 154

ZAPOTEC. 151–154: Human figure with elaborate stylized headdress, and a variety of geometric figures. Sash.

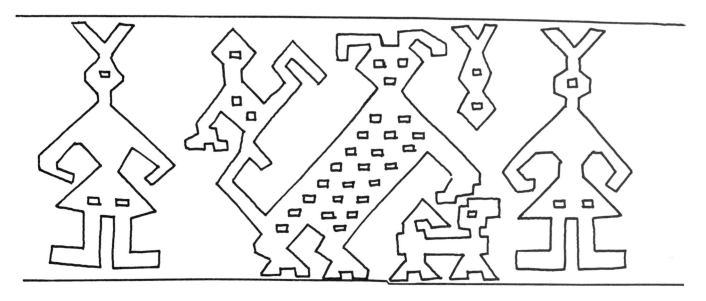

155

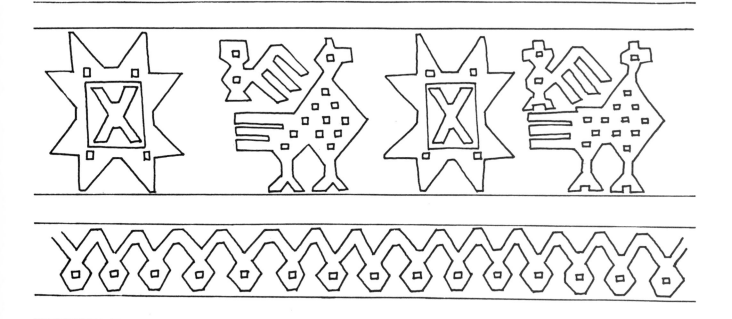

156

Zapotec. 155: Row of dolls, geometric figures and a prancing animal with a monkey balancing on its tail. Woman's tunic. 156: Cross bands containing 8-pointed stars with X-units centered in them; they alternate with pairs of birds. Rare old woman's tunic.

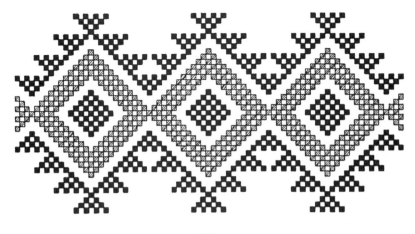

157

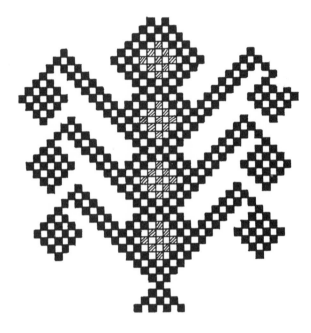

158

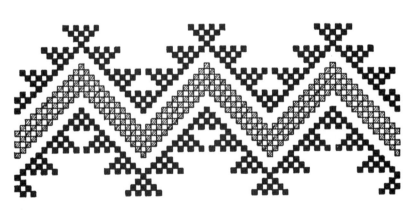

159

ZAPOTEC. 157: Geometric motif of diamonds with serrated borders. Old woman's tunic.
158: Stylized plant form (corn?). Old woman's tunic. 159: Zigzag motif with serrated
borders. Old-style head covering.

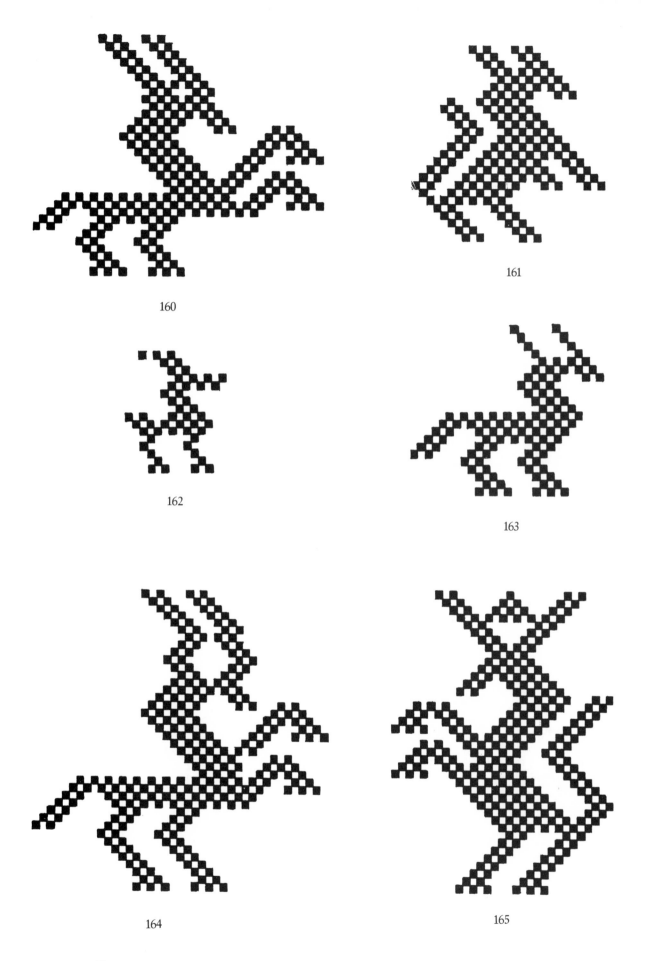

160

161

162

163

164

165

ZAPOTEC. 160–165: Various animals (horses, dogs, goat, mule). Woman's tunic and
head covering.

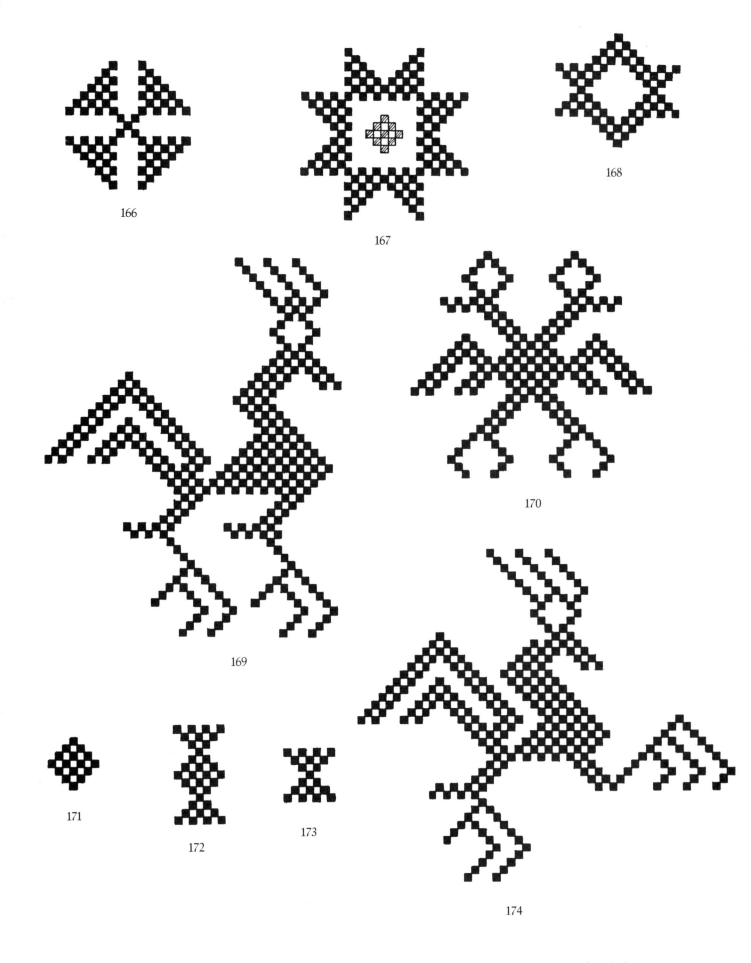

166

167

168

169

170

171

172

173

174

ZAPOTEC. 166–174: Geometric motifs, and eagles, one of which is double-headed.
Woman's tunic.

64

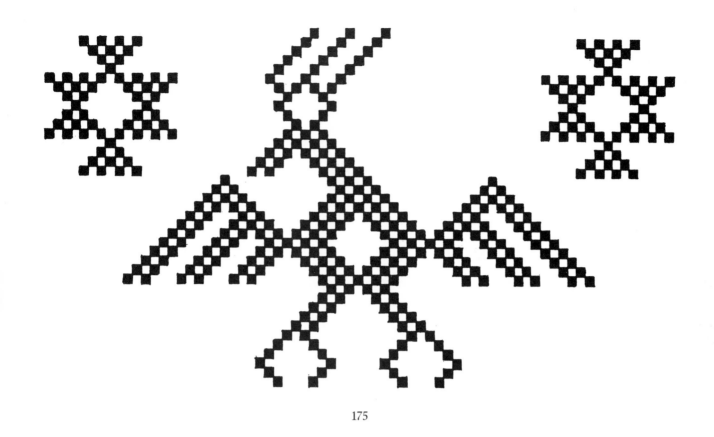

175

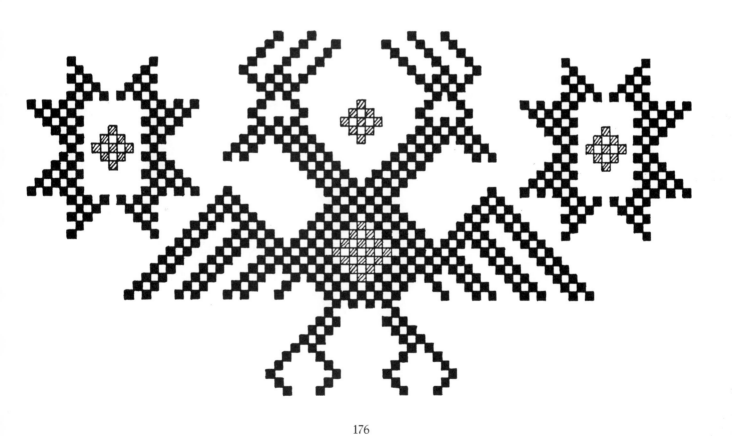

176

ZAPOTEC. 175: Eagle flanked by geometric units. Old woman's tunic. 176: Double-headed eagle flanked by stars. Woman's tunic.

177

178

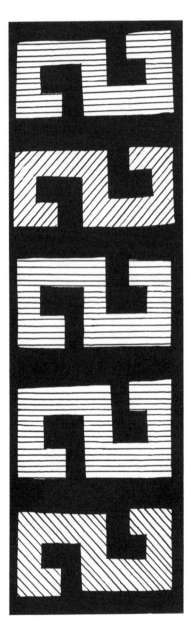

179

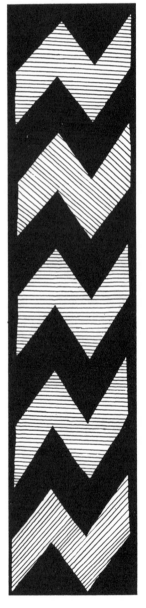

180

MIXTECO. 177–180: Simple geometric shapes within cross bands; motifs are reminiscent of stone mosaics at Mitla ruins. Woman's tunic.

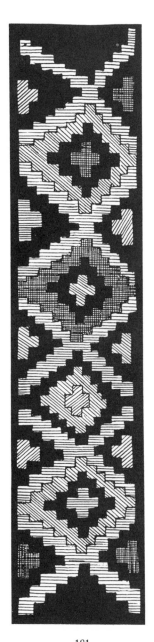

181

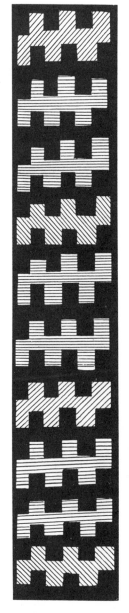

182

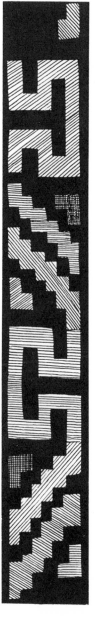

183

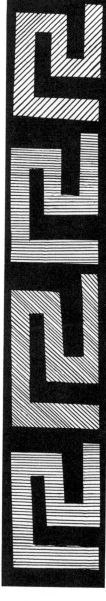

184

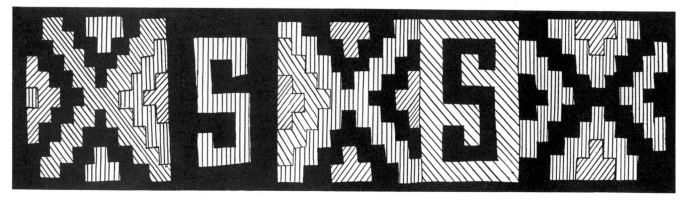

185

MIXTECO. 181–185: Elaborations of repeated geometric designs incorporating stepped-fret and diamond motifs. Mitla-like designs. Woman's tunic.

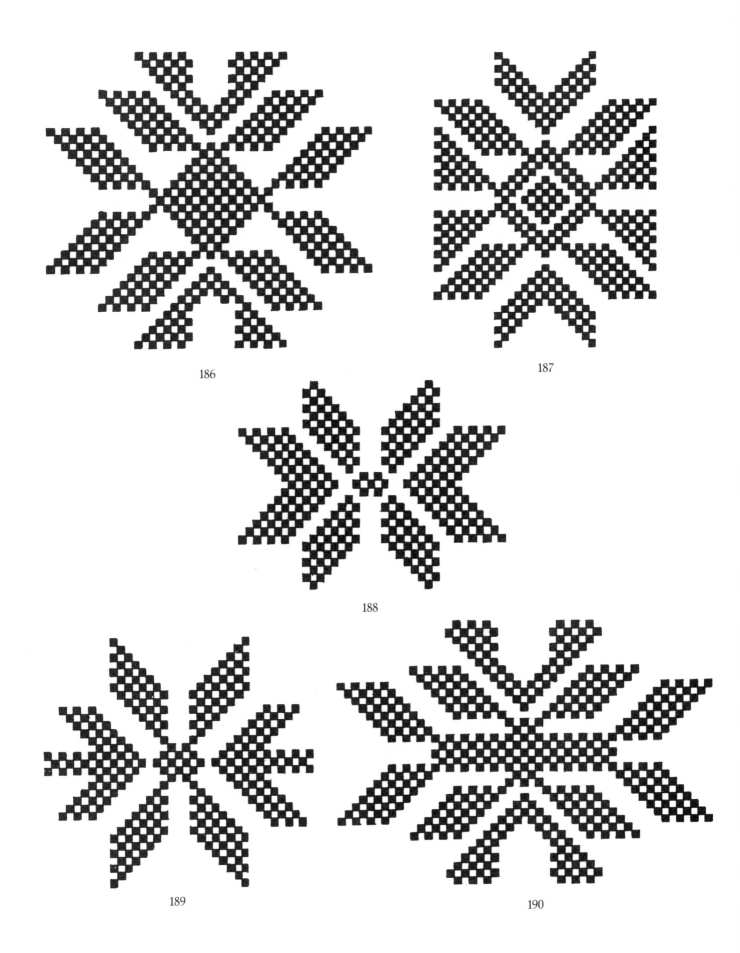

186

187

188

189

190

MIXTECO. 186–190: Variety of stylized floral motifs. Woman's tunic.

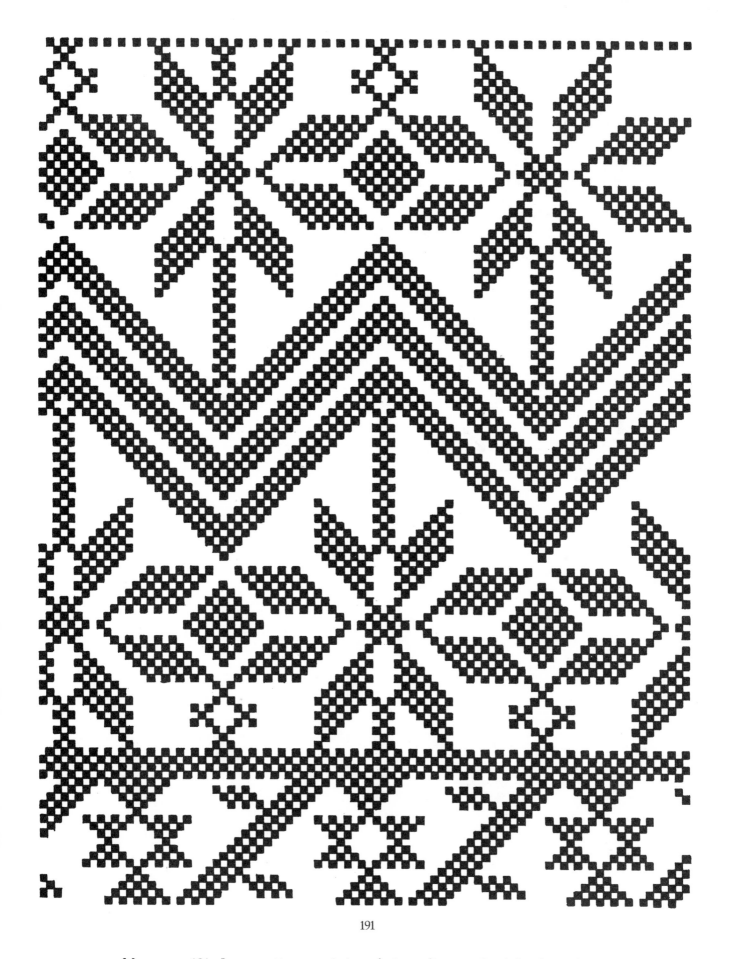

191

MIXTECO. 191: Large pattern consisting of zigzag lines, stylized floral motifs and geometric units. Woman's tunic.

192

193

194

MIXTECO. 192: Row of 8-pointed stars. 193: Row of highly stylized birds in flight.
194: Row of diamonds with serrated edges. All from head coverings.

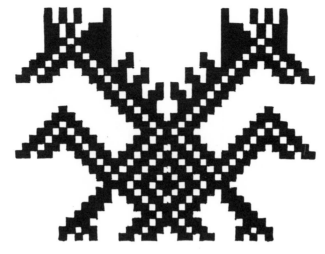

195

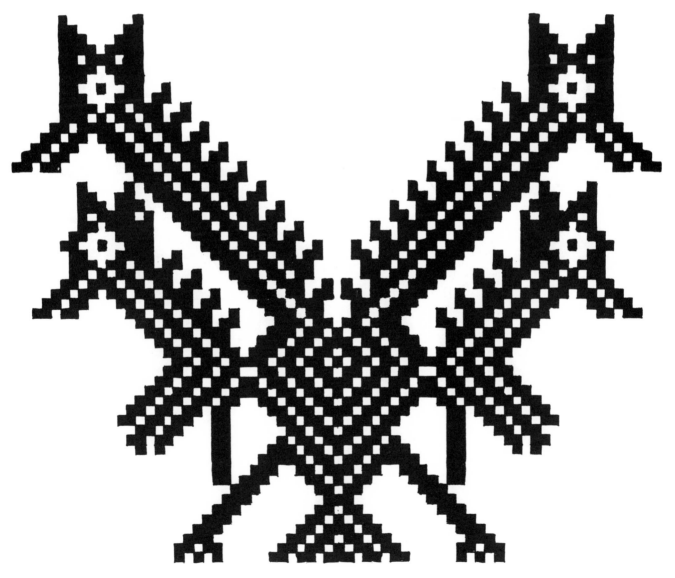

196

Mᴉxᴛᴇᴄᴏ. 195, 196: Variants of multiheaded birds. Woman's tunic.

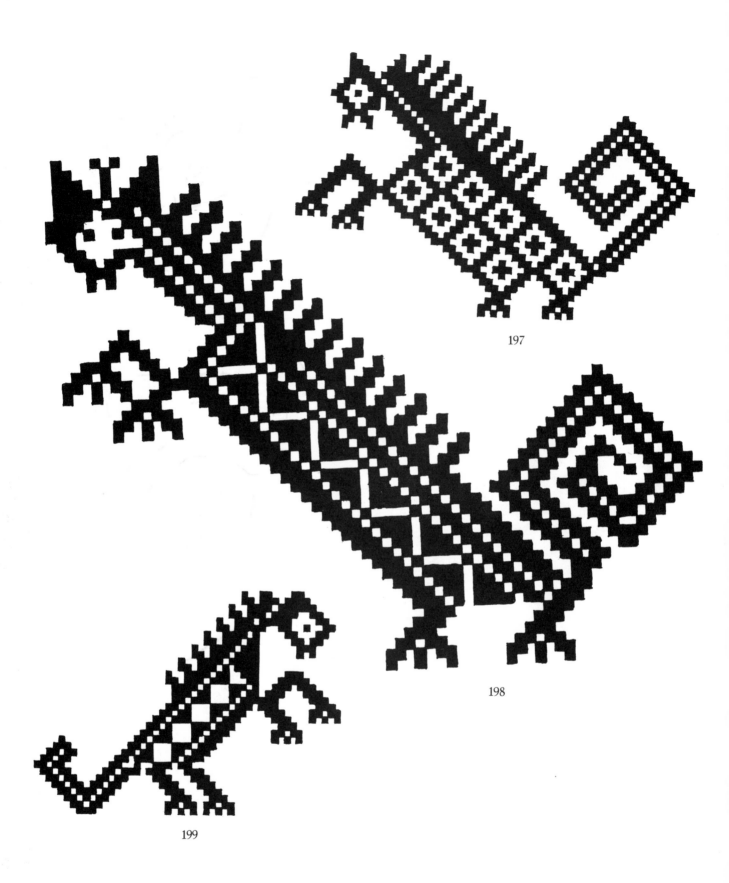

197

198

199

72 MIXTECO. 197–199: Prancing animals with long tails. Woman's tunic.

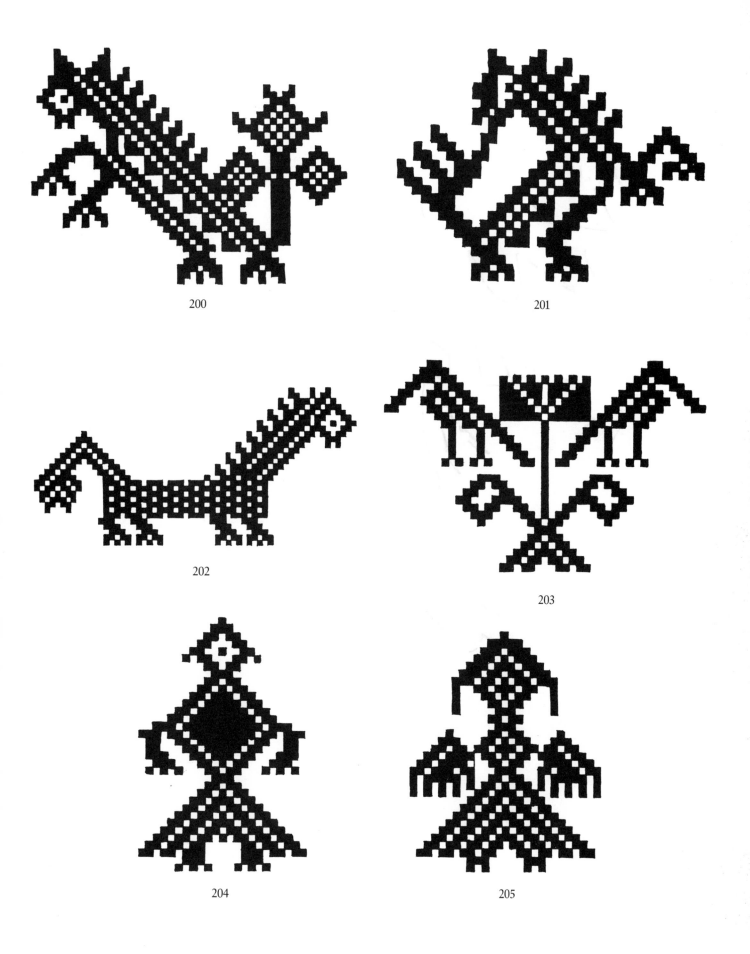

200

201

202

203

204

205

MIXTECO. 200–202: Various animals (rodent, iguana?) standing or prancing.
203: Plant with birds. 204, 205: Male and female figures. All from woman's tunic. 73

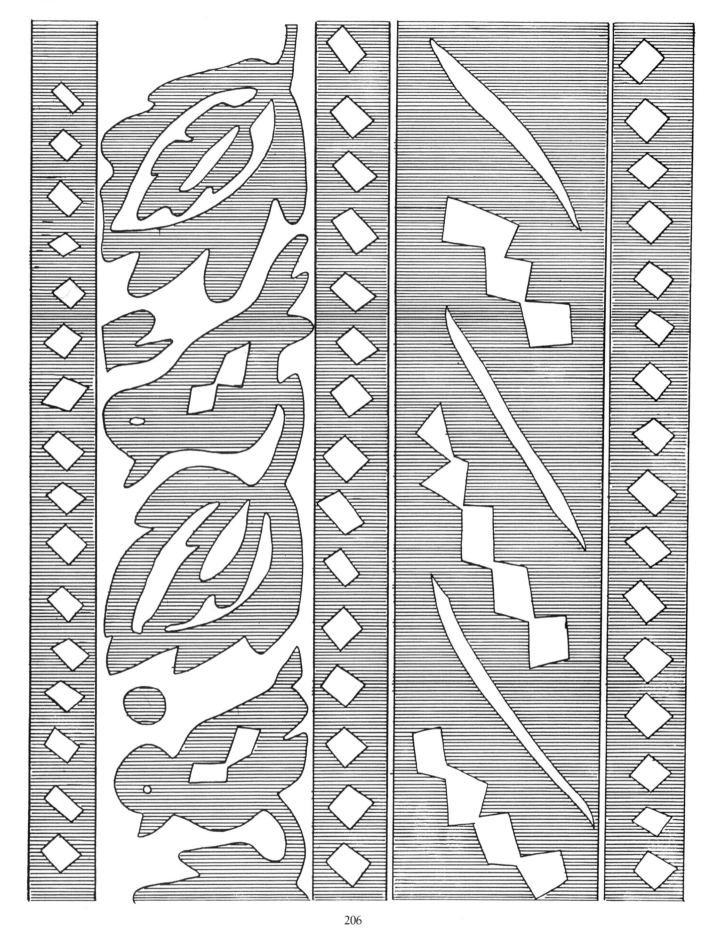

206

MAZATEC. 206: Narrow cross bands containing repeated diamond shapes separating wider bands; one exhibits alternating bird and leaf motifs, the other shows graceful geometric motifs. Old-style woman's shoulder cape.

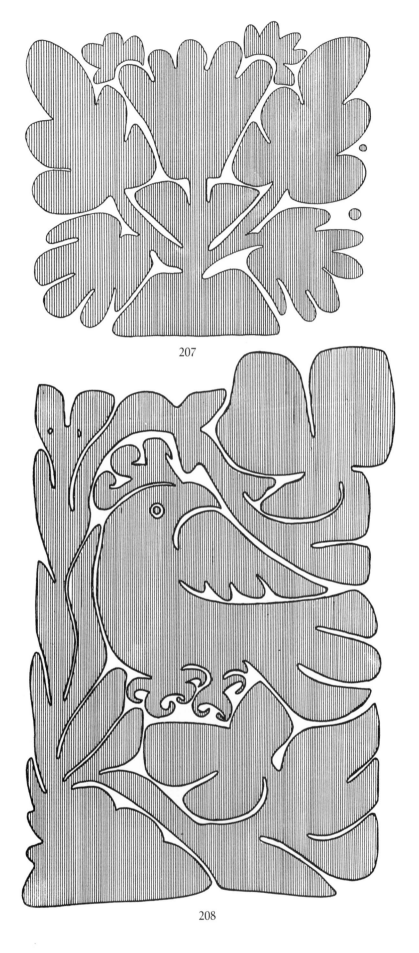

207

208

M<small>AZATEC</small>. 207: Floral and leaf pattern. Woman's tunic. 208: Plant growing from the ground, artfully concealing a crested bird. Woman's tunic.

209

210

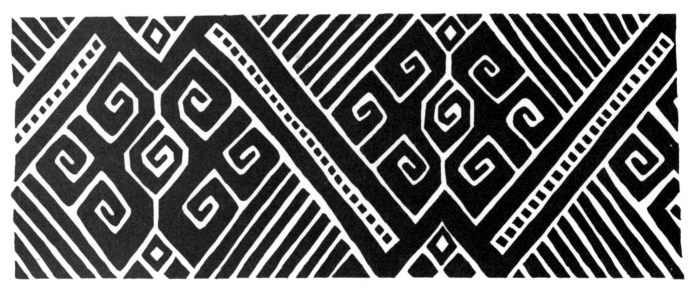

211

MAZATEC. 209: Repeating pattern of five interlocking, serrated spirals, the fourth contrasting in color with the others; example of "blond serpent" motif. Wraparound skirt. 210, 211: Variants of diagonal bands with hook or spiral motifs. Woman's tunic.

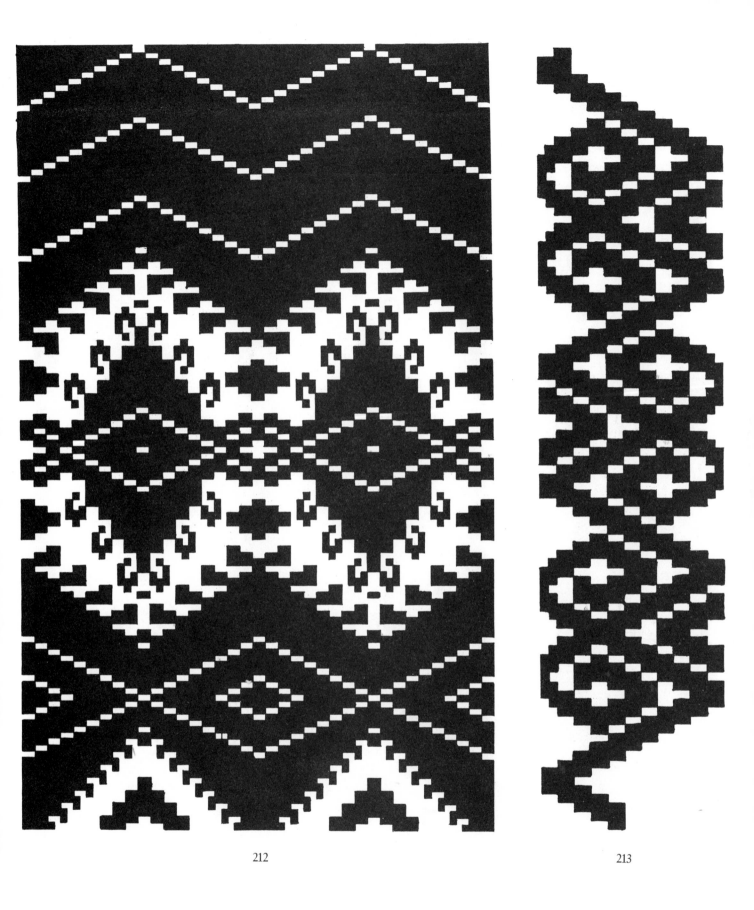

212

213

CUICATEC. 212: Wide cross bands containing repeating diamond-within-diamond pattern with hook motifs at edges. Mortuary sheet. 213: Geometric pattern of vine and spirals. Woman's tunic.

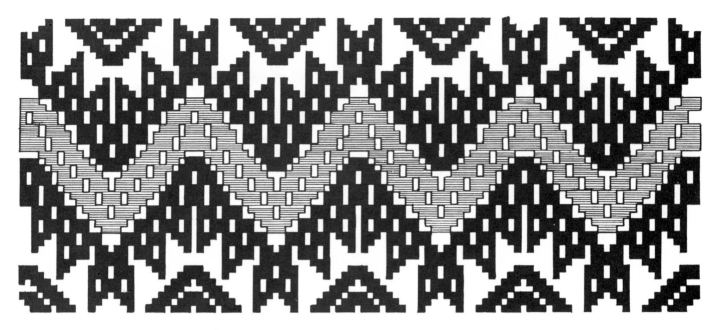

214

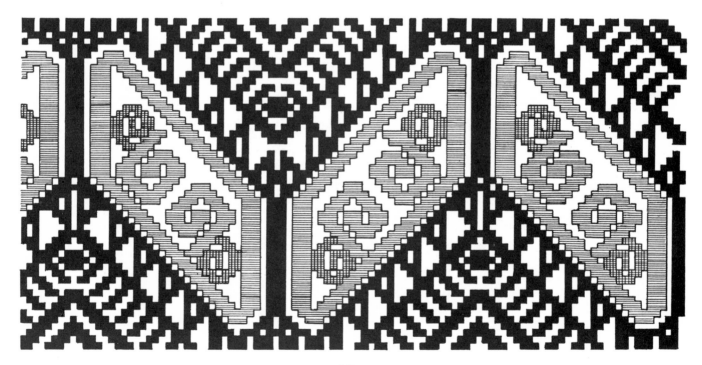

215

CUICATEC. 214: Wide zigzag line with serrated edges, symbolizing feathered serpent. Woman's tunic. 215: Pattern of parallelograms set diagonally to form zigzag arrangement; inside are placed hook motifs; chevrons and serrated lines fill triangular areas. Woman's tunic.

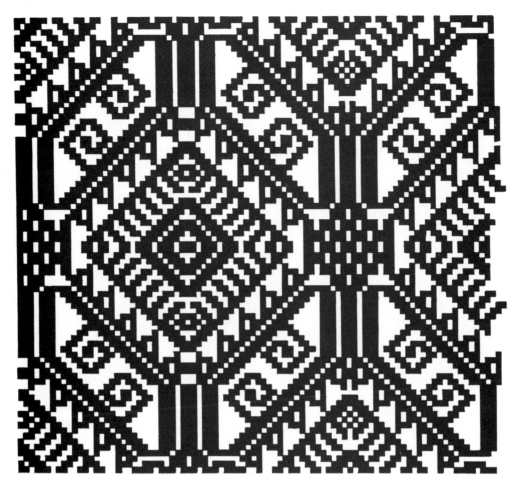

216

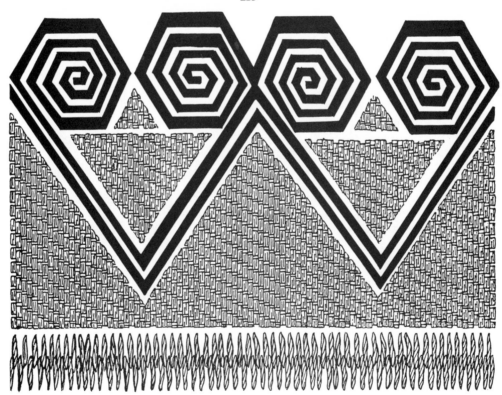

217

CHINANTEC. 216: Pattern of diamond-within-diamond, hook and spiral units, and stepped diagonals. Woman's tunic. 217: Pairs of zigzag lines from which emerge angular spiral motifs. Woman's tunic.

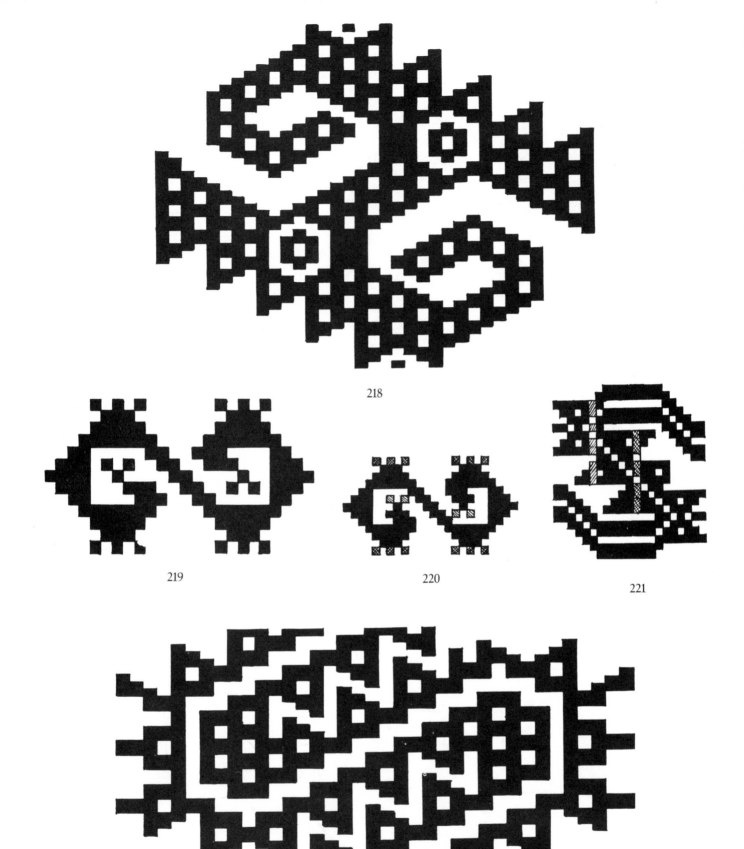

218

219 220

221

222

CHINANTEC. 218: Bilateral stepped-fret motif. 219, 220: Variants of S-motif.
221: Example of Flower of Powder motif. 222: Example of serpent motif. All from
woman's tunic.

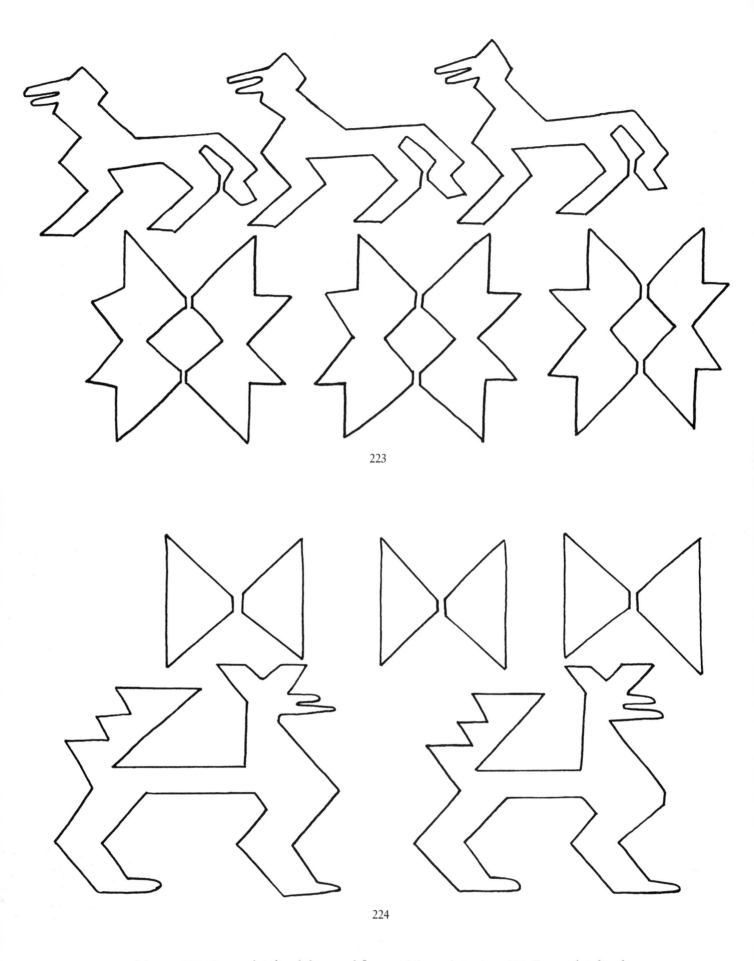

223

224

MIXE. 223: Rows of stylized dogs and flowers. Woman's tunic. 224: Rows of stylized
animals (foxes?) and butterflies. Woman's tunic. 81

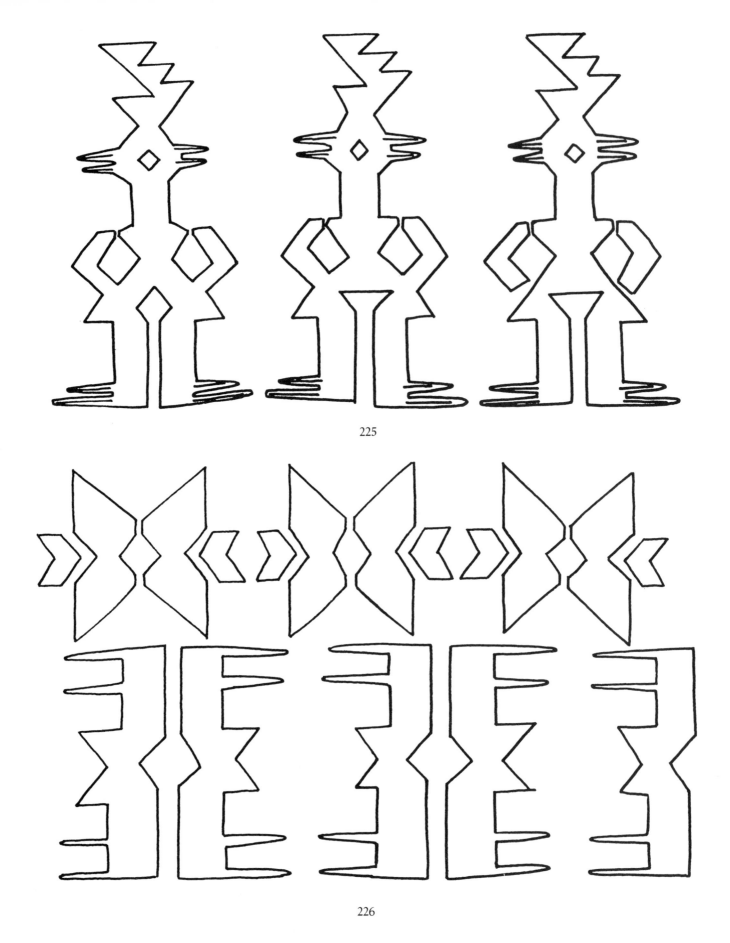

225

226

MIXE. 225: Anthropomorphic figures exhibiting animal characteristics (beak? crest?).
Woman's tunic. 226: Combination of flower-like motifs set over countered and paired
abstract designs (bats? butterflies?). Woman's tunic.

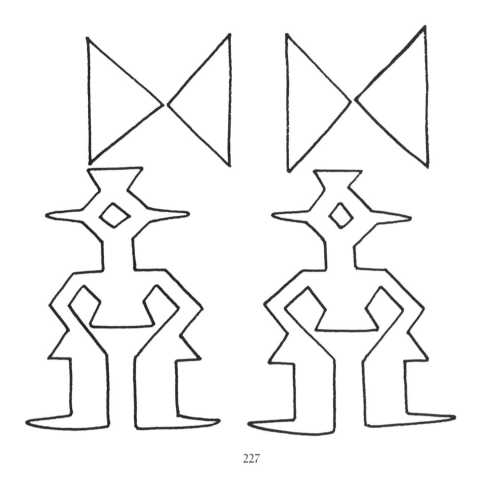

227

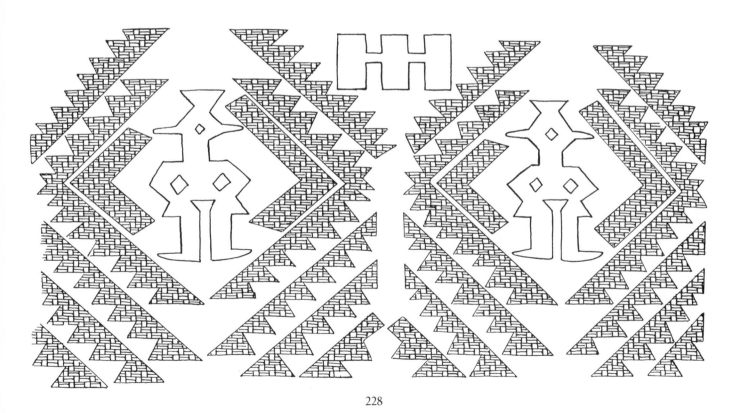

228

MIXE. 227: Bird-like anthropomorphic figures with countered and paired triangles. Woman's tunic. 228: Large pattern of serrated diamond-within-diamond motif surrounding bird-like anthropomorphic figures and a double-H motif. Woman's tunic.

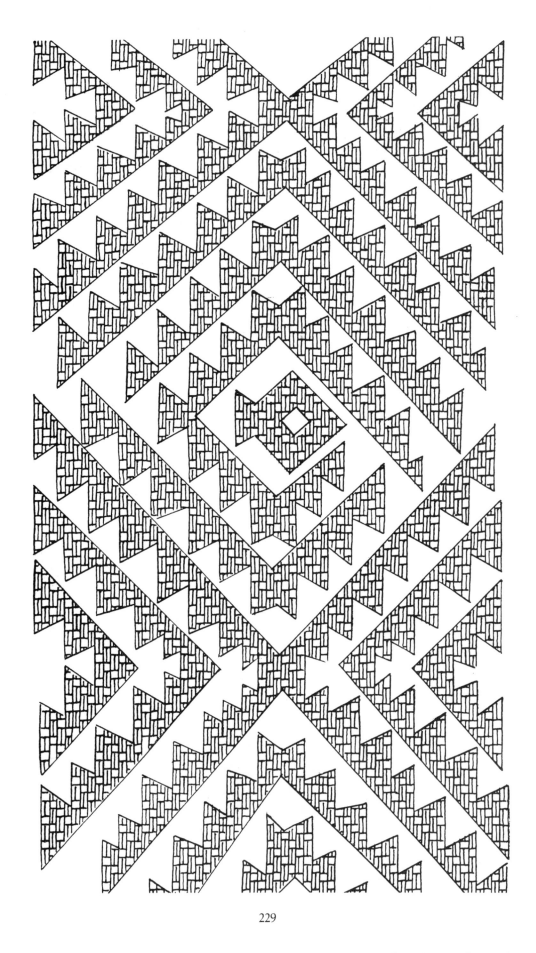

229

MIXE. 229: Irregular arrangement of serrated diamond-within-diamond motif. Woman's tunic.

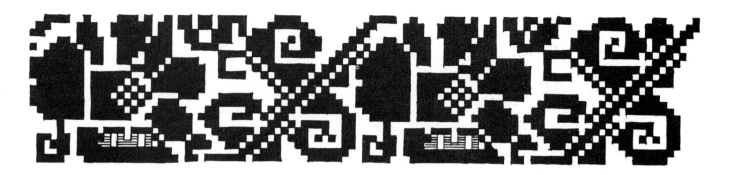

230

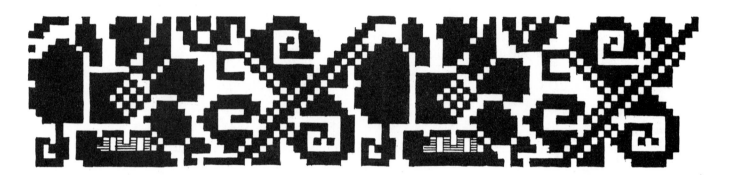

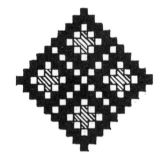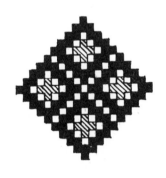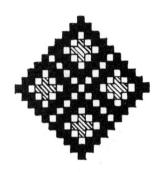

231

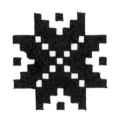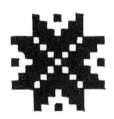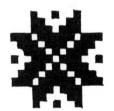

232

CHATINO. 230: Conventionalized vine motif. Yoke for woman's blouse. 231, 232: Free-standing geometric shapes. Square cloth used for covering food, or for ceremonial purposes.

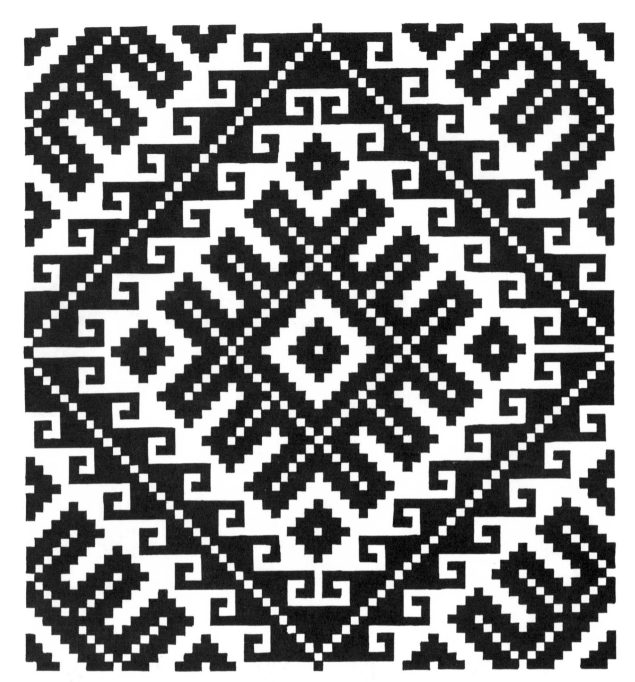

233

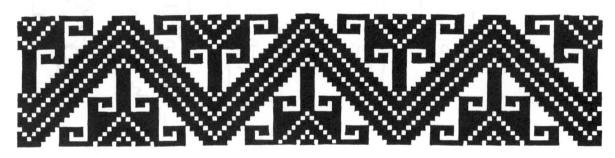

234

CHONTAL. 233: Large diamond-within-diamond and hook-motif pattern. Ceremonial
cloth. 234: Cross band depicting zigzag, chevron and hook motifs. Ceremonial cloth.

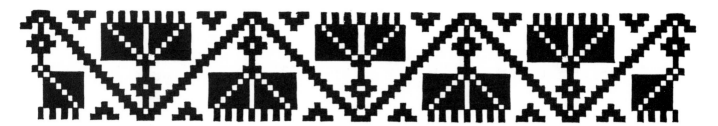

235

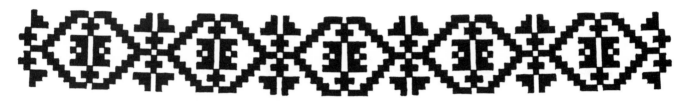

236

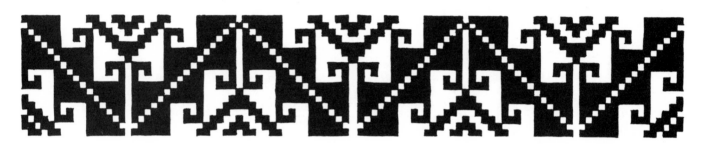

237

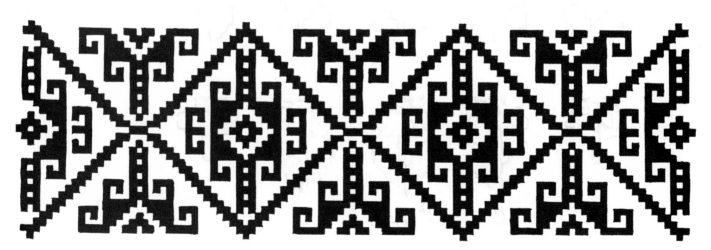

238

CHONTAL. 235–238: Various patterned cross bands showing geometric and stylized floral motifs. Ceremonial altar cloth.

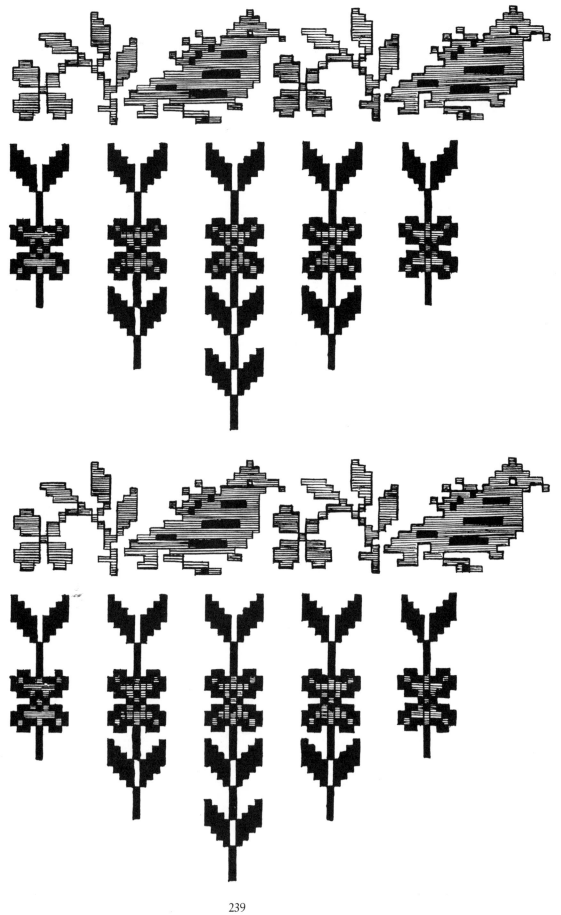

239

CHONTAL. 239: Alternating bird and flower motifs. Woman's blouse.

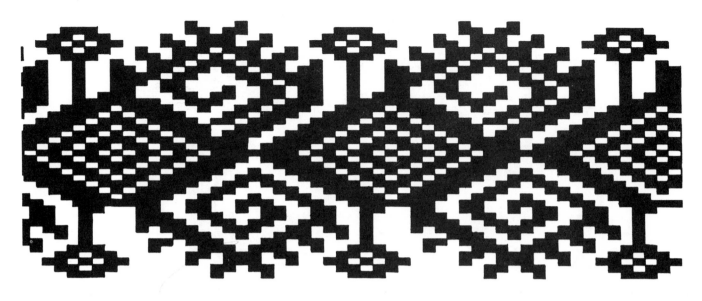

240

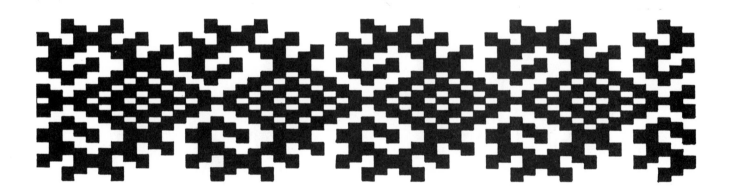

241

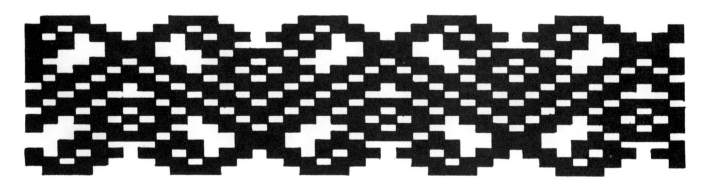

242

Tzotzil. 240–242: Various cross bands containing diamonds, angular spirals, zigzag lines and hook motifs. Woman's tunic.

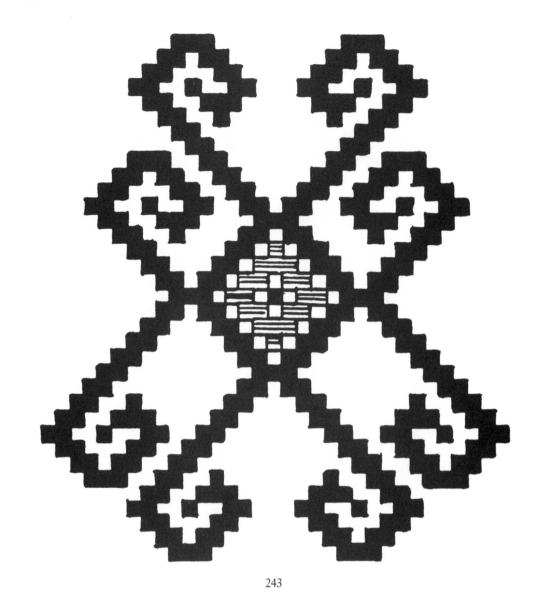

243

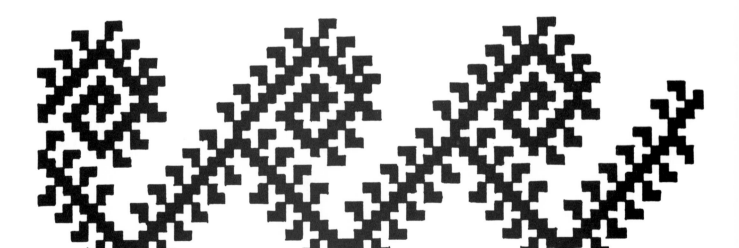

244

Tzotzil. 243: Central diamond giving rise to paired spirals emerging from each corner.
Shawl. 244: Border of zigzag lines and angular spirals with serrated edges. Shawl.

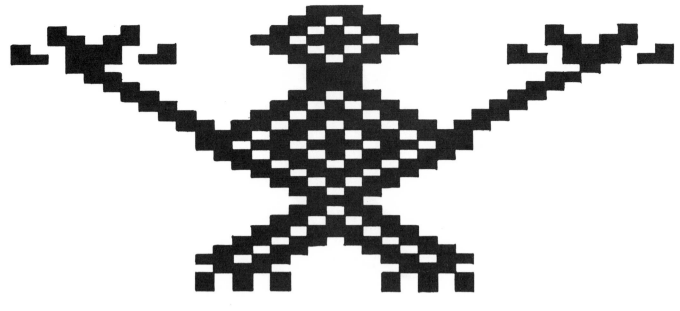

245

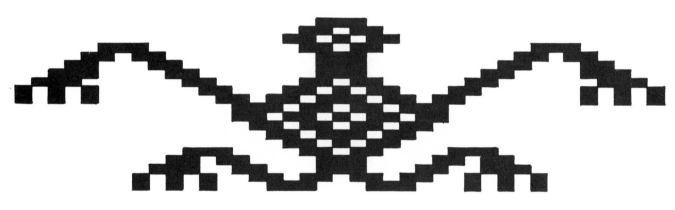

246

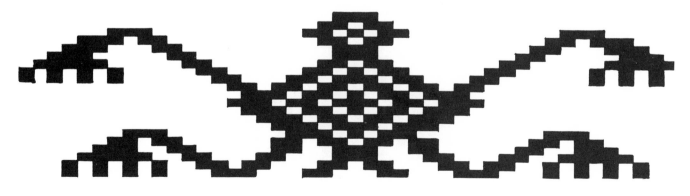

247

TZOTZIL. 245–247: Three examples of "monkey" motif. Old woman's tunic. 91

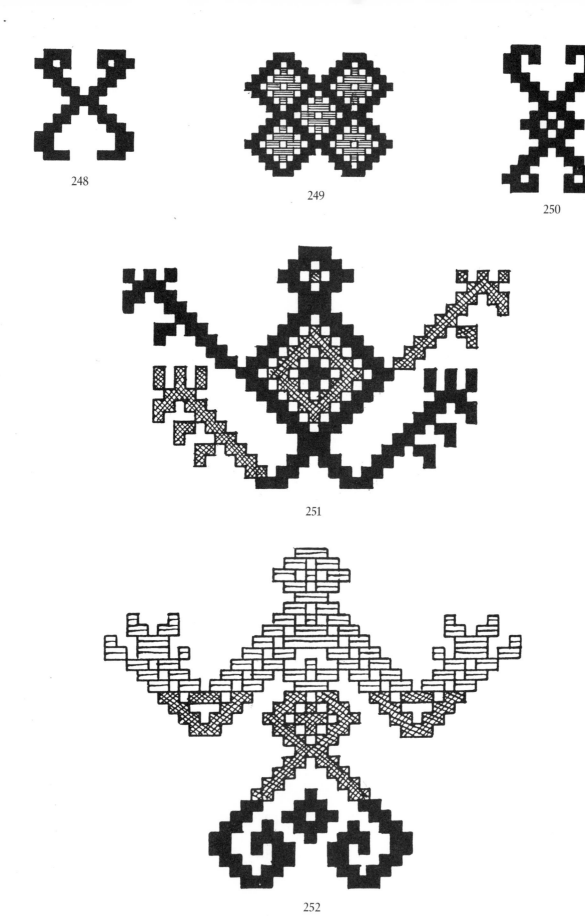

248 249 250 251 252

Tzotzil. 248, 250: Small X-motifs with hooks curved inwards. Shawl. 249: Small design of diamond motifs forming a cross. Shawl. 251, 252: Variants of stylized monkey motif. Woman's shoulder cape.